A Diverse History: Texas, the Lower South, and the Southwest before 1900

The David B. Warren Symposium

Volume 7

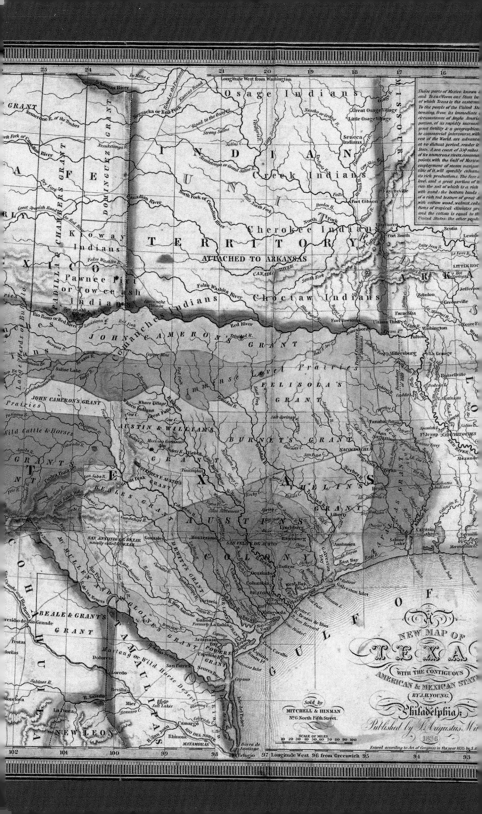

A Diverse History:
Texas, the Lower South, and
the Southwest before 1900

The David B. Warren Symposium

Volume 7

Bayou Bend Collection and Gardens
The Museum of Fine Arts, Houston

Heather Brand, Head of Publications
Edited by Christine Waller Manca and Megan Smith
Book design by Kristin Liu
Printing by Masterpiece Litho, Inc.

Printed in the United States of America

Library of Congress Control Number:
2019954726

Front cover: Antonio Pérez de Aguilar, *The Painter's Cabinet* (detail), Mexico, 1769, oil on canvas, 49 ¼ x 38 ⅛ in. (125 x 98 cm), Museo Nacional de Arte, Mexico City.

Back cover: Elkington & Co., *Inkstand* (detail), 1864–65, silver and glass, 13 ¾ x 26 x 9 ½ in. (34.9 x 66 x 24.1 cm), the Museum of Fine Arts, Houston, the Bayou Bend Collection, gift of the estate of Miss Ima Hogg, B.76.186.

Frontispiece: Samuel Augustus Mitchell, *A New Map of Texas, with the Contiguous American and Mexican States* (detail), 1836, the David Rumsey Historical Map Collection.

The 2019 David B. Warren Symposium was made possible with generous support from:
The David B. Warren Symposium Endowment
Humanities Texas, the state affiliate of the National Endowment for the Humanities
Nancy Glanville Jewell
Marilyn G. Lummis
John L. Nau III
The Summerlee Foundation

If you would like to support the endowment fund for the biennial David B. Warren Symposium, please send your contributions to Bayou Bend Collection and Gardens, P.O. Box 6826, Houston, Texas 77265-6826.

Contents

Foreword

The biennial David B. Warren Symposium is a shining example of Bayou Bend's steadfast commitment to the study and appreciation of pre-1900 Texas material culture. With this volume, we enter our second decade of publishing the symposium proceedings, continuing to advance and enrich printed scholarship in the field. Complimentary copies of the book will be sent to nearly 250 research libraries across the nation.

Bayou Bend's decades-long interest in the heritage and artistic traditions of nineteenth-century Texas began in the 1960s with founder Ima Hogg, who had a strong desire to better understand what Texans crafted for their use and enjoyment. Her passion has been shared by many over the years, but perhaps none more so than longtime Bayou Bend supporter and friend William J. Hill (1934–2018), whom we lost while planning for the 2019 symposium was under way.

Bill Hill had a laser focus and an inveterate collector's eye when it came to Texas decorative arts and paintings. His enthusiasm was boundless, and over the course of more than five decades he "gathered" (his word) one of the finest and largest Texas collections in the country. Bill's collecting fervor was only exceeded by his Texas-sized philanthropic spirit. Thanks to his extraordinary generosity, giving literally hundreds of Texas objects to Bayou Bend over many years, today we are pleased to have on public display one of the most important collections of nineteenth-century Texas decorative arts and paintings, in particular several significant examples of furniture, silver, and pottery.

Bill believed Bayou Bend should be at the forefront of research on early Texas material culture. He championed and then underwrote the 2012 establishment of a major internet-based initiative, rightly named in his honor, the William J. Hill Texas Artisans and Artists Archive. Bill also was a strong supporter of the Warren Symposium from its inception. In recognition of all he did to further awareness of and research about the nineteenth-century heritage of Texas, this volume is dedicated to William J. Hill, a sixth-generation Texan who did so much to enrich the field of Texas material culture; his legacy will be lasting and his footprint will never be matched.

Left: William J. Hill in the Texas Room at Bayou Bend, 2010.

This publication is composed of papers that were delivered at the seventh biennial David B. Warren Symposium, held at the Museum of Fine Arts, Houston, on February 22–23, 2019. The papers address the overarching theme: "A Diverse History: Texas, the Lower South, and the Southwest before 1900." The range of topics and theses reflect the diversity of cultures that existed in this region from the prehistoric period through the late nineteenth century.

As anyone who has helped present a scholarly conference knows, many dedicated, knowledgeable individuals work for months planning the content and managing the logistics. Special recognition is due the advisory committee, which selected the symposium theme and the slate of speakers. The advisory committee was made up of members of the curatorial, education, and library staff of the Museum of Fine Arts, Houston, and two Austin-based professionals, Dr. Rowena Houghton Dasch, executive director of the Neill-Cochran House Museum, and Candace Volz, president and decorative arts historian of Volz and Associates, Inc. I am indebted to all of the Bayou Bend staff behind the scenes, who made the two-day program such a smoothly run and enjoyable event for all of the participants.

Heartfelt thanks go to the following individuals and foundations for their continuing belief in and financial support of the symposium series: Humanities Texas, the state affiliate of the National Endowment for the Humanities; Nancy Glanville Jewell; Marilyn G. Lummis; John L. Nau III; and the Summerlee Foundation. Significant support has also been provided by proceeds from the David B. Warren Symposium Endowment.

Bonnie A. Campbell
Director
Bayou Bend Collection and Gardens

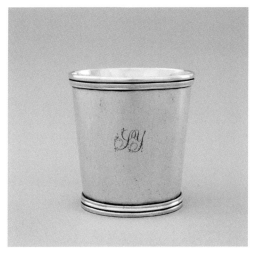

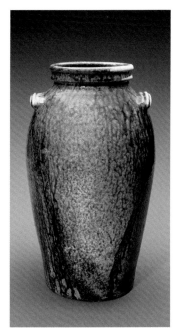

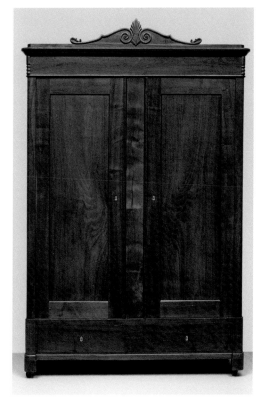

Works of art given by William J. Hill to Bayou Bend (clockwise from top):

Samuel Bell, **Tumbler,** *c. 1851–60, silver, the Bayou Bend Collection, gift of William J. Hill, B.2018.7.*

John Davis Leopard, **Jar,** *c. 1850–83, alkaline-glazed stoneware, the Bayou Bend Collection, gift of William J. Hill, B.2012.93.*

Johann Michael Jahn, **Wardrobe,** *c. 1860–70, black walnut; pine and bone, the Bayou Bend Collection, gift of William J. Hill, B.2007.25.*

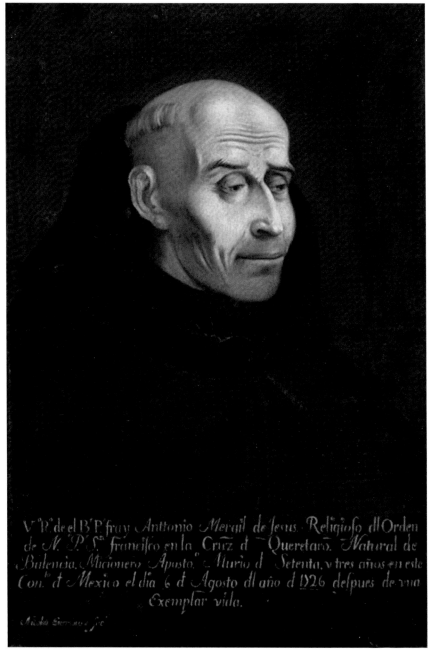

V.ᵉ P.ᵉ de el B.ᵗᵒ P. fray Anttonio Merail de Jesus. Religioso dl Orden de N. P. S. francisco en la Cruz d Queretaro. Natural de Balencia, Micionero Aposto.ᵒ Murio d Setenta, y tres años en este Con.ᵗᵒ d Mexico el dia 6 d Agosto dl año d 1726 despues de vna Exemplar vida.

Nicolas Enriquez fec.

Fig. 1. Nicolás Enríquez (New Spain), **Fray Antonio Margil de Jesús**, mid-eighteenth century, oil on canvas, 47 x 31 in. (119.9 x 78.7 cm), Our Lady of the Lake University, San Antonio.

They Walked Among Us:
Six Who Shaped Eighteenth-Century Texas

Marion Oettinger, Jr.

We Americans have yet to really learn our own antecedents . . . we tacitly abandon ourselves to the notion that our United States have been fashioned from the British Islands only . . . which is a very great mistake.[1]
 —Walt Whitman, *The Spanish Element in Our Nationality*, 1883

In 2018 the city of San Antonio celebrated the tricentennial of its founding, and the San Antonio Museum of Art joined this auspicious occasion by organizing a special exhibition of Mexican viceregal painting and sculpture made during the first century of the life of San Antonio and Texas. Geographically, the exhibition concentrated primarily on the art related to the general area of Mexico City to the northern Texas border of New Spain. Aside from the remains of a dozen or so important eighteenth-century Franciscan Texas missions, five of which are located in San Antonio, there is a dearth of art that has survived the ravages of time, war, weather, and neglect in Texas. In the absence of documented viceregal art from Texas, we were compelled to look elsewhere for visual artistic expressions that reflected the religious beliefs, governing individuals and institutions, aspects of social structure, material culture, and economic activities that would have been familiar to Texas residents, whether itinerant or permanent. We visited dozens of great public and private museums in Mexico, and ultimately ninety-five percent of exhibition loans came from those generous sources. A total of 125 works of art comprised the exhibition, many of them portraits. Six of these portraits, religious and secular, represent little-known individuals who resided in different parts of Texas during the eighteenth century, and whose lives greatly impacted the history of Texas more than a century prior to Texas Independence in 1836. Their names and faces need to be seen and remembered.

Fray Antonio Margil de Jesús (1657–1726)
The Franciscans were the first mendicant order authorized to baptize and convert indigenous populations after the fall of Tenochtítlan in 1521.[2] The "Original

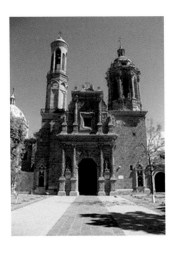

Left:
Fig. 2. Church of Our Lady of Guadalupe, Zacatecas, Mexico.

Right:
Fig. 3. Mission San José y San Miguel de Aguayo, San Antonio.

Twelve," led by Fray (Friar) Pedro de Gante, arrived in 1525 and established special colleges in central Mexico to teach fundamentals of Christianity and other cultural aspects of western European culture. Just as their founder San Francisco de Asis (Saint Francis of Assisi) had modeled his life after the life of Christ, so too did these missionaries emulate the sacrifices of San Francisco. Fray Antonio Margil de Jesús and his fellow devotees arrived in the late seventeenth century during a period of renaissance of Franciscan missionary activity, and with substantial political and financial support from Madrid as well as Rome (fig. 1).

Fray Antonio Margil de Jesús was famous during his lifetime as an exemplary Franciscan friar, a brilliant and passionate evangelist, a gifted scholar of indigenous languages, and a zealous worker for the Catholic Church. Known especially for his humble demeanor, he walked barefoot to all his posts throughout New Spain and fasted almost every day of the year. He customarily signed his name *La Misma Nada*, or Nothingness Itself. Although still on the path to canonization, he is often referred to as the "Patron Saint of Texas."

Fray Margil was born in Valencia, Spain, in 1657 and took the Franciscan vows there at the age of sixteen. In 1682 he joined Fray Antonio Llinás, the recently appointed leader of a new, aggressively evangelistic initiative in New Spain known as *Propaganda Fide*, designed to establish new apostolic colleges and regional missions in some of the most isolated parts of New Spain. He departed for Mexico in 1683 and had the good fortune of sharing ship quarters with Fray Llinás. Later that year, with Llinás as founder and Margil as cofounder, they began construction of the Colegio de Propaganda Fide de la Santa Cruz de Querétaro, located about 150 miles north of Mexico City. Over the next decade, Fray Margil, ever the dedicated and tireless field-

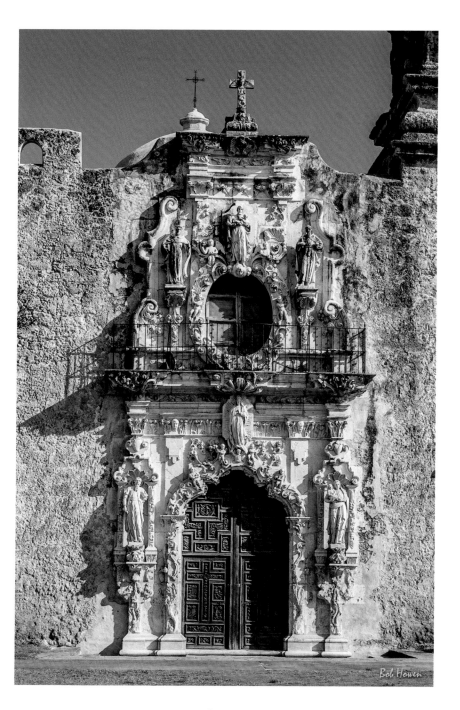

Bob Howen

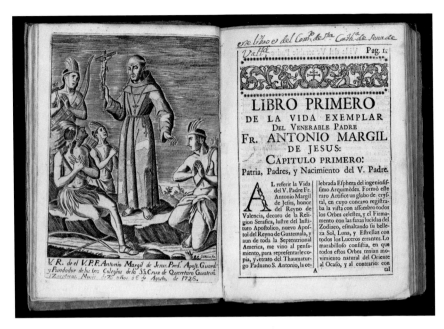

Fig. 4. Fr. Isidro Félix de Espinosa, **Fr. Antonio Margil de Jesús Preaching to Indigenous People of Northern New Spain***, 1737, engraved frontispiece, Elizabeth Huth Coates Library, Trinity University, San Antonio.*

worker, established missions in Costa Rica, Nicaragua, Yucatan, and Guatemala. In 1701, while in Antigua, Guatemala, he began the future College of Christ Crucified (El Convento del Colegio de Cristo de Recoletos de Nuestra Padre San Francisco).[3]

Margil was called back to Querétaro, and shortly thereafter, in 1706, he was sent further north into a semi-settled zone referred to as La Chichimeca, or La Comancheria, to found the Colegio Apostolico (Apostolic College) de Nuestra Señora de Guadalupe in the rich mining region of Zacatecas, a move designed to train new missionaries, build new missions, and support deeper incursions into northern New Spain—primarily parts of Coahuila, Nueva León, and Texas (fig. 2). After rival Spanish/French politics intensified along the northeastern border of New Spain, Fray Margil, with support and protection from the governor of Coahuila and Texas, the Marqués de San Miguel de Aguayo, closed Spanish missions in East Texas (some founded earlier by Margil), rescued staff, indigenous converts, and sacred religious objects and moved the entire operation to the more secure community of San Antonio. In 1720 Margil founded three missions there, the most important of which was Mission San José y San Miguel de Aguayo (fig. 3). While residing in San Antonio

4

and surrounding communities, his health began to decline, and he started a long and arduous return to Zacatecas, Querétaro, and Mexico City, where he died in 1726 at the church of San Francisco. Margil was buried in the National Cathedral. His close colleague and fellow Franciscan friar Isidro Félix de Espinoza wrote and published Margil's biography in 1737, celebrating his extraordinary life and extolling his many virtues. The frontispiece of this rare publication shows Margil dressed as a mendicant and evangelizing indigenous people of northern New Spain, probably from Coahuila or Texas (fig. 4). His remains were reburied in 1983 on the grounds of the Colegio Apostolico de Nuestra Señora de Guadalupe in Zacatecas, the institution he founded.[4]

Throughout the viceregal period, most religious orders of the Americas used visual and performing arts to instruct nonliterate indigenous people, as well as religious novitiates, about the lives of Christ, the Virgin, and others who represented essential tenets of Christian faith and to provide visual likenesses of exemplar deceased members of their order, some of whom had been martyred. Margil was instrumental in the use of religious art, especially paintings and sculptures, for teaching in the college in Zacatecas and elsewhere. *The Mystical City of God* (1706) by Cristóbal de Villalpando is one of many important works by this great Baroque painter found in Zacatecas (fig. 5). Art historian Jaime Cuadriello firmly believes that Fray Margil commissioned this work, which includes depictions of Saint John the Evangelist and of Sister María de Ágreda, a Spanish mystic whose writings on the Virgin of the Immaculate Conception provided inspiration for the later evangelization of northern New Spain.[5] Other outstanding early eighteenth-century painters were also commissioned by the college at the time of its founding, and portraits of Margil as a mendicant were painted during the middle of that century by anonymous artists. In addition, likenesses of Fray Margil were included, decades after his death, in a series of twenty-four large canvases dedicated to the life of San Francisco (c. 1752) by Mexican painter Antonio de Oliva, as well as in a massive stairwell mural (c. 1765) by Miguel Cabrera, one of the most important painters of the middle to late eighteenth century.

Fray Margil, like many of his Franciscan contemporaries, strongly supported theatrical performances as a means of instruction. These presentations included illustrations of the birth, suffering, death, and resurrection of Christ, as well as dramatic reenactments of the miraculous apparitions of the Virgin and the miracles of important saints. Many similar dramatic performances are still enacted today throughout Mexico and in many parts of South Texas.

Margil's zealous devotion to his calling and his persistent attention to needs of the missions he oversaw inspired later generations of evangelists, most famously Fray Junípero

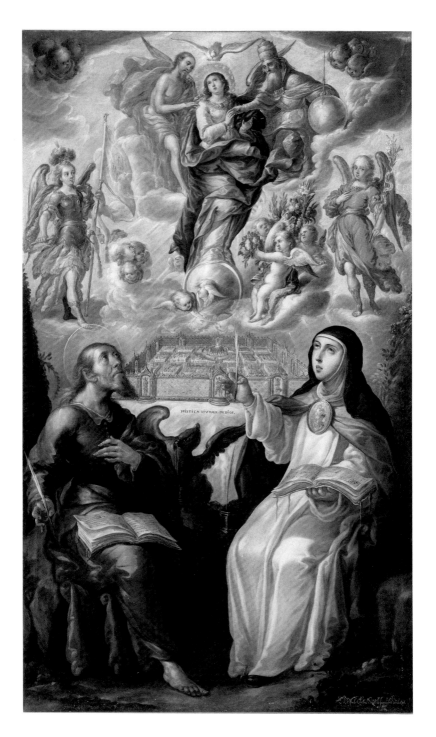

MISTICA CIVDAD DE DIOS.

Left:
Fig. 5. Cristóbal de Villalpando, **The Mystical City of God***, c. 1706, oil on canvas, 71 x 45 in. (180.3 x 114.3 cm), Museo de Guadalupe, Secretaría de Cultura, INAH, MX, Zacatecas.*

Above:
Fig. 6. José de Páez, **Martyrdom of Franciscans at Mission San Sabá***, c. 1765, oil on canvas, 93 x 126 in. (236 x 320 cm), Museo Nacional de Arte, Secretaría de Cultura, INBA, Mexico City.*

Serra (1713–1784), the storied founder of the missions of California, who considered Margil his most influential mentor. Serra was canonized by Pope Francis in 2015.[6]

Fray Alonso Giraldo de Terreros (1699–1758)

During the eighteenth century, the northern border of New Spain shifted frequently within Texas, depending on Spanish and French politics, economics, and changing military strategies. By the middle of the century, the Spanish had pushed even further north in order to establish a more secure defense against indigenous groups that strongly opposed Spanish incursions into their traditional territory, as well as to meet an increasingly bellicose border dispute with the French. By 1756, the Spanish crown authorized the establishment of the Presidio (Fort) San Luis de las Armarillas,

named in honor of the viceroy, and a new Franciscan mission, known as Santa Cruz de San Sabá. The new establishments would be located along the San Sabá River, about 130 miles north of San Antonio, and would mainly attend to the spiritual needs of the Lipan Apache Indians in the area. A wealthy miner and merchant in Querétaro and Pachuca, Don Pedro Romero de Terreros, the Count of Regla, had offered to underwrite the project under the condition that his cousin Fray Alonso Giraldo de Terreros be appointed president of the mission.

Fray Terreros was born in Cortegana, Huelva, in Spain in 1699 and was taken to New Spain while still a child. He took the Franciscan habit at the Apostolic College of Santa Cruz, in Querétaro, in 1721. For three decades he served many Franciscan missions in East Texas and along the Rio Grande. By the time he was appointed to lead Mission San Sabá, Fray Alonso was a well-respected, seasoned missionary. His close associate was Fray José Santiesteban (1719–1758), who was born in Navarro, Spain, and took his Franciscan vows in Pamplona in 1749; a year later, Santiesteban moved to New Spain, where he entered the Apostolic College of San Fernando in Mexico City. Terreros and Santiesteban, along with other religious and secular personnel, arrived in San Antonio in December 1756 to await the readiness of the San Sabá Mission and nearby presidio. They left San Antonio for San Sabá in April 1757. For much of the first year, their missionary enterprise was met with indifference from the natives and various other disappointments, and several missionaries withdrew in despair. On March 16, 1758, a large force of Comanche, Wichita, and aligned groups attacked the mission, killing Terreros by lance and musket and Santiesteban by beheading. Because the establishment of the San Sabá Mission had been such an ambitious enterprise, and due to its patronage by the powerful Count of Regla, the destruction of the mission and the deaths of religious and non-religious personnel became subjects of intense discussion throughout New Spain and beyond. Formal investigations began soon thereafter, and dozens of surviving eyewitnesses gave their accounts of the destruction of the mission and the martyrdom of the two priests.

Around 1765, Don Pedro Romero de Terreros commissioned a large and important painting of this tragic event in memory of his slain cousin Fray Terreros, Fray Santiesteban, and others who died (fig. 6). Firmly attributed to the great Mexican viceregal artist José de Páez, *Martyrdom of Franciscans at Mission San Sabá* is the earliest known painting depicting Texas and one of the most important historical paintings in the Americas. It shows in powerful detail the destruction of the mission and the violent deaths of the two martyrs. The standing figure on the left represents Fray Terreros, and that on the right depicts Fray Santiesteban. People and vignettes are shown as if

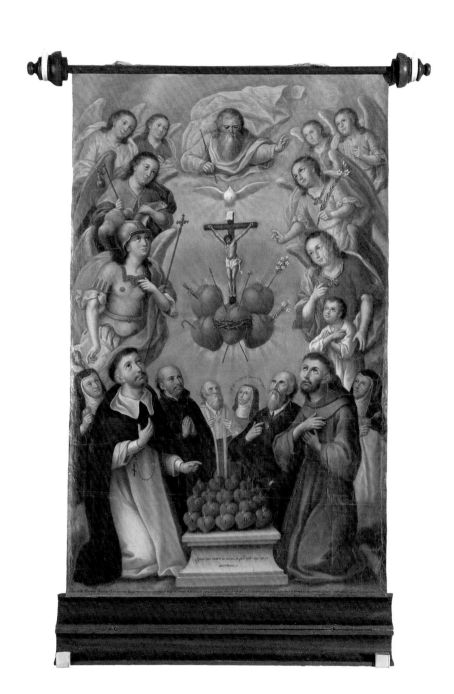

Fig. 7. Unknown artist, **Religious Orders Adoring the Sacred Heart of Jesus**, *mid-eighteenth century, scroll, oil on canvas, 37 x 25 in. (94 x 63.5 cm), Museo de Historia Mexicana, Monterrey, Mexico.*

frozen in time, perhaps intending to represent the exact moments when musket balls, lances, and knives ended lives of those slain.[7] It dramatically captures Terreros's distant gaze, upward toward heaven, and the intense stare of Santiesteban as it focuses on the crucified Christ—the very moments their earthly lives end and their eternal spiritual lives begin. Compositionally, these portraits frame the frightening events that unfolded on that fateful day, including a key at the bottom identifying the players, settings, and episodes. Most likely heavily informed by eyewitness accounts, albeit from a Spanish perspective, this dramatic painting provides the viewer with valuable information about religious, military, and indigenous attire; weaponry; equine culture; settlement patterns; and flora and fauna. The mission's defensive palisaded complex is central to the composition, and the military presidio at the upper left corner blends into the distant landscape. The rudimentary chapel and living quarters suggest what Texas missions may have looked like in their earliest days. Perhaps the most dramatic scene is the sacking of the chapel and the destruction of the image of Our Lady of Refuge,

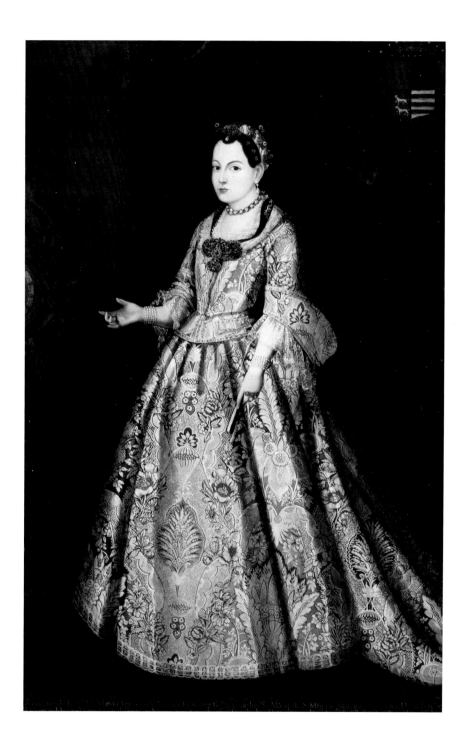

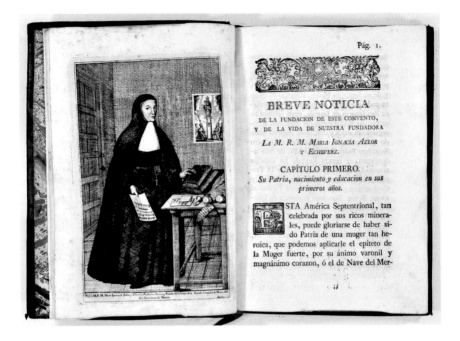

*Fig. 10. Unknown artist, **Sor María de Azlor y Echeverz**, 1793, frontispiece engraving, DeGolyer Library, Southern Methodist University, Dallas.*

patron and protector of the mission. Her image was painted on canvas and rolled up in the form of a scroll painting, suitable for travel and safe storage while not in use. The use of scroll paintings to transport and store images related to Christian historical scenes and saints and Virgins can still be found in Mexican churches today, some still in use (fig. 7).

Don José Ramón de Azlor y Virto de Vera (1668–1734)

Don José Ramón de Azlor y Virto de Vera, the second Marqués de San Miguel Aguayo, and his wife, Ignacia Xaviera de Echeverz y Valdés (died 1733), were the largest and wealthiest landholders in eighteenth-century northern New Spain. Don José served as provincial governor of Coahuila and Texas from 1719 to 1722. During his tenure as governor, he traveled widely in Texas. Apparently appreciative of the necessity to establish firm religious institutions, an effective local secular government, and a strong professional military, he put great energy, money, and influence behind all three types of settlement life. Don José and his wife funded the construction and decoration of nascent churches and missions in Coahuila, Texas, and other new settlements in the north. In 1720 he supported and accompanied Fray Antonio

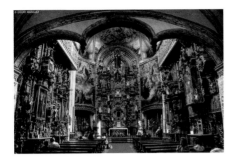

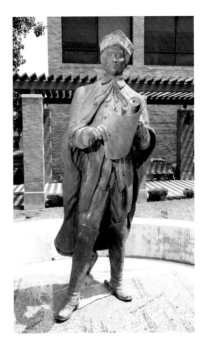

Above:
Fig. 11. **Main Retablo of Our Lady of the Pilar Convent**, *Mexico City.*

Right:
Fig. 12. *Roberto Garcia, Jr.,* **Don Joseph de Escandón y Helguera**, *2014, bronze, University of Texas Rio Grande Valley, Edinburg, Texas.*

Margil de Jesús as Franciscan missions in East Texas were either bolstered, or abandoned and reestablished in San Antonio for better security. For this reason, the name of the Mission San José y San Miguel Aguayo includes his name saint. The official report of that trip, published in 1722, contains an early map of San Antonio, showing its location between the San Pedro and San Antonio rivers and featuring illustrations of local flora and fauna. It also includes an ambitious plan for a fort or presidio that was never built as represented here (fig. 8). Don José supported construction of San Antonio's irrigation system, or *asequias*, and backed the emigration of settlers from the Canary Islands who later established San Antonio's first civil government in the early 1730s, several years after the Marqués's death.

Perhaps the most interesting and philanthropic member of the Don José's family was his daughter Doña María Ignacia de Azlor y Echeverz (1715–1767), who after the death of her parents, traveled to Spain in 1737 and joined a Franciscan religious sisterhood (fig. 9). In 1745 she became a nun and received a royal license from King Phillip V to found a convent in Mexico City, using her mother's Echeverz family inheritance (fig. 10). The convent of La Enseñanza, dedicated the teaching of young, impoverished girls, and the associated church of Our Lady of the Pilar are located just a few blocks from the Zócalo, and represent the best of Mexican Baroque exuberance (fig. 11).[8]

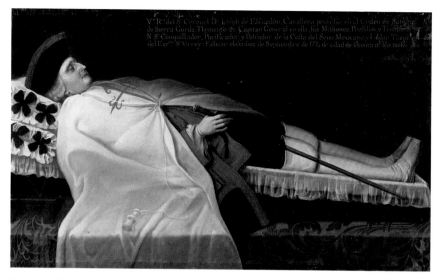

Fig. 13. Andrés de Islas, **Don Joseph de Escandón y Helguera,** *c. 1770, oil on canvas, 47 x 80 in. (119.4 x 203.2 cm), Museo Regional de Querétaro, Secretaría de Cultura, INAH, MX, Mexico.*

Don Joseph de Escandón y Huelguera (1700–1770) The first Count of Sierra Gorda, Don Joseph de Escandón y Huelguera, was an important figure in the colonization and development of northeast Mexico and parts of South Texas. Born in Soto de Marina, Santander, Spain, in 1700, he left his native country at an early age to become a cadet in the cavalry of the city of Merida, Yucatan. His valor while serving in the Spanish military led to a major promotion and transfer to the prosperous mining city of Querétaro, and his skills in successfully engaging and subduing local indigenous groups of the Sierra Gorda earned him the reputation as "a tenacious conqueror" of the Sierra Gorda, an area long famous for its resistance to Spanish rule and conversion to Catholicism.[9] His defeat of indigenous people and rebel miners in Guanajuato and Irapuato increased his reputation as an effective, albeit at times brutal, soldier. Due partly to growing threats from English and French forces in the Gulf of Mexico, Escandón was named Governor of Nueva Santander in the 1740s and was placed in charge of the colonization of the vast region of northeast Mexico that today includes the states of Nueva León, Tamaulipas, and parts of South Texas. Between 1748 and 1755, he founded more than twenty towns along the Rio Grande, including Laredo, Reynosa, Mier, and other important communities.

Statues and markers acknowledging his historical importance are located as far north of the border as Alice, Texas, and the University of Texas Rio Grande Valley campus (fig. 12). Andrés de Islas's posthumous portrait of Count of Sierra Gorda bespeaks his wealth and power. Nearly life-sized, he is shown lying in state, dressed in his uniform with sword and spurs and wearing a cape of the Order of Santiago (fig. 13). During his lifetime, Escandón accumulated vast wealth, and in the late 1760s, he was charged with exploitation of indigenous labor and other forms of corruption. He died in Querétaro in 1770, during the trial. Five years later he was exonerated of legal charges against him.

Don Hugo O'Conor (1734–1779)

With the arrival of the Bourbon monarchs in Spain in the early eighteenth century, administrative reforms, territorial shifts, and new artistic styles and fashions eventually made their way to New Spain. Part of this period also witnessed a more ethnically diverse leadership in Spanish colonies. Throughout the viceroyalties of the Americas, the Spanish crown appointed many talented military and political leaders from origins other than Spanish, especially French and Irish, to introduce and enforce reforms and changing policies. Don Hugo O'Conor was part of this new leadership, and his many talents led to major changes in northern New Spain during the 1760s and 1770s.

O'Conor was born in Dublin in 1734, part of an illustrious family that descended from the last king of Connaught, who lost his throne in 1224. Hugo's father and grandfather were both fervently anti-British control and strong supporters of an independent Ireland. Hugo was like-minded politically and was, as was the case of most of the O'Conor family, a devout Catholic. In 1751 Hugo expatriated himself to Spain, where he joined other Irish Catholic aristocrats, often referred to as "Wild Geese Irish." According to O'Conor family tradition, a portrait (fig. 14) represents one of several O'Conors who fought for Spain, perhaps Hugo himself. An older cousin, Alejandro O'Reilly, who was an important, well-connected member of the Spanish military and later destined to become the second governor of Louisiana, quickly recognized the talents of his young relative and strongly backed his rise through the military ranks.[10] After participating in various Spanish campaigns in Europe, O'Conor was transferred to Cuba, where he served under the command of Field Marshall Alejandro O'Reilly. In 1765 O'Conor was sent to Veracruz and Mexico City. Due to his military accomplishments and the unflagging backing of O'Reilly, Viceroy Marqués de Cruillas sent O'Conor to Texas to explore and report on a delicate and growing political-corruption scandal there. He was

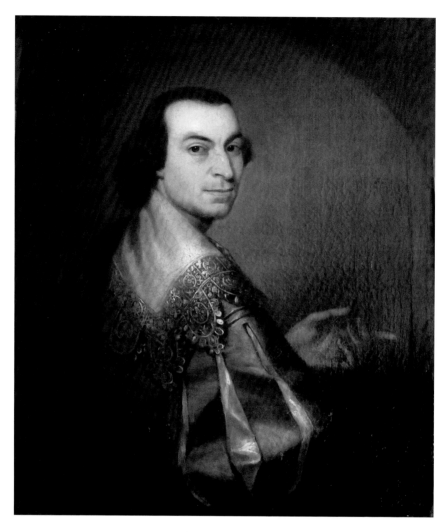

Fig. 14. Unknown artist, **Don Hugo O'Conor** *(tentatively identified), eighteenth century, oil on canvas, Clonalis House, Castlerea, County Roscommon, Ireland.*

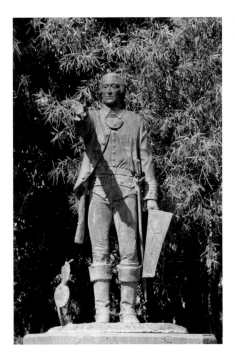

given extensive powers, and eventually O'Conor guided the difficult matter to resolution. Consequently, he was appointed Inspector General of the Interior Provinces, a position that he accepted with great energy. Most of the new inspector general's time was spent establishing or shoring up presidios in Texas and creating new techniques for defending them against hostile indigenous tribes, especially the Apaches and Comanches. His aggressive military actions and his distinctive red hair earned him the nickname of "The Red Captain."[11] In 1767 he was named Governor of Texas and spent much of his time in San Antonio, the most populous in the area at that time. He remained strongly Catholic and always attended mass before leaving on military campaigns. In 1768 Fray Gaspar José de Solís was sent to inspect the missions that had been established by the Franciscans from the apostolic college of Guadalupe, Zacatecas. Solís was greatly impressed with San Antonio's missions, and on March 19, after visiting San José mission, he wrote that "a mass of thanks was sung, and afterwards I blessed the foundation and first stones for the church that is just beginning to be built in this mission. Don Hugo O'Conor laid one and I the other. This church is going to be made of stone and lime, with arches fifty varas long and ten varas wide in the transept."[12]

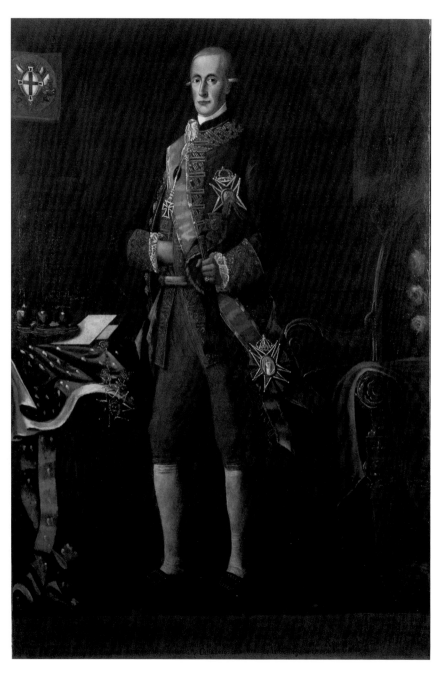

*Fig. 16. M.L. de Yncháustequi , **Don Teodoro de Croix**, c. 1790, oil on canvas, 80 x 56 in. (203.2 x 142.2 cm), Autry Museum, Los Angeles.*

Between 1771 and 1776, O'Conor, by then with the rank of colonel, was in charge of securing the communities on the northern frontier of Nueva Viscaya, Coahuila, and Sonora and establishing or refurbishing presidios in regions subject to raids by Apache and other groups. In 1775 O'Conor established the presidio in Tucson, Arizona; he thus is considered the founder of that city (fig. 15). Many years of traveling and making war in the often harsh environments of northern New Spain began to take their toll, and O'Conor was sent to the Yucatan Peninsula with the titles of governor and brigadier general. He died in 1779 at Quinta Miraflores, on the outskirts of Merida. He was forty-four years old.

Don Teodoro de Croix (1730–1792)

Another non-Spanish leader was appointed to assume the position of Inspector General of the Interior Provinces immediately following Hugo O'Conor. Teodoro de Croix was born into an aristocratic Flemish family. He joined the Spanish army at the age of seventeen and was sent to New Spain in 1766, when his uncle Don Carlos Francisco de Croix was appointed viceroy in service to the Bourbon kings of Spain. Several years later, he was named to the lucrative position of Governor of Acapulco, a position held for four years. Because of his administrative training, military background, and his close association to those at the highest levels of power in Mexico City and beyond, including the highly skilled Gálvez family, de Croix was appointed Commandant General of the Internal Provinces of the North, encompassing the vast regions of Nueva Viscaya, the Californias, Coahuila and Texas, Nueva León, and New Mexico. He is credited with strengthening security of the territories and increasing the number of Native American conversions to Christianity. By some accounts, he was not the hands-on type of administrator that characterized O'Conor in the same position, but his military experience and political savvy helped make his time in New Spain successful. De Croix traveled to most regions under his direction, including many parts of Texas. He visited San Antonio on several occasions and held numerous meetings with landowners to deal with ranch reform and taxation.[13]

In 1783 de Croix was appointed viceroy of Peru, a position he held until his return to Spain in 1790; he died there shortly afterward. A portrait of de Croix (fig. 16), one of several surviving likenesses painted in Peru and Spain, was taken during his time as viceroy and is similar to one in the collection of Peru's Museo Nacional de Arqueología, Antropología e Historia, Lima. He is shown in viceregal attire, holding a Peruvian *bastón de mando* or staff of authority and wearing insignia of the Order of Carlos III and the Cross of the Teutonic Order.[14]

The six individuals profiled here were widely known in their times. They were soldiers, clergy, and wealthy patrons who made significant contributions to the establishment and evolution of Texas society during the eighteenth century. They were praised, feared, admired, loved, and emulated by people who knew them. We are fortunate that their portraits have survived and continue to remind us of their deeds. It is hoped that more likenesses of other people of accomplishment will be brought to light in the future. Those discussed here were wealthy and were influential in other ways, thus attracting the attentions of patrons and artists, but they represent a very small part of the population. Most people led lives that remain obscure, but they, too, dreamed and acted on their dreams, often at great risk to the safety of themselves and their family. These quiet and unknown settlers, soldiers, and priests, whose faces we will never know, sank deep roots into early Texas, and they deserve our thoughts and acknowledgment.

Notes

This essay was made possible primarily through the generosity of over a dozen national and private museums in Mexico. I would also like to thank Gabriela Gámez, Betsy Beckmann, Heather Fulton, and the Museum of Fine Arts, Houston, for their valuable assistance.

1 Walt Whitman, "The Spanish Element in Our Nationality," letter to the *Philadelphia Press*, 1883.

2 Christina Cruz González, "A Second Golden Age: The Franciscan Mission in Late Colonial Mexico," in *San Antonio 1718: Art of Mexico*, ed. Marion Oettinger, Jr. (San Antonio: Trinity University Press and San Antonio Museum of Art, 2018), 53.

3 Eduardo Enrique Ríos, *Life of Fray Margil, OFM*, translated revised by Benedict Leutenegger (Washington, DC: Academy of American Franciscan History, 1959).

4 Marion Oettinger, Jr., ed., *San Antonio 1718: Art of Mexico* (San Antonio: Trinity University Press and San Antonio Museum of Art, 2018), 140.

5 Jaime Cuadriello, "In the Footsteps of Sor María de Jesús and Fray Margil de Jesús," in Oettinger, *San Antonio 1718*, 46.

6 Stephen W. Hackel, *Junípero Serra: California's Founding Father* (New York: Hill and Wang, 2013), 35.

7 Pedro Ángeles Jiménez, "La destrucción de la misión San Sabá y martirio de los padres Fray Giraldo de Terreros y Fray José de Santiesteban," in *Memoria 5* (Mexico City: Museo Nacional de Arte, 1994), 4–33.

8 Katherine McAllen, "Time and Space on the Missionary Frontier: Cultural Dynamics and the Defense of Northern New Spain," in Oettinger, *San Antonio 1718*, 13–14.

9 Ilona Katzew, ed., *Contested Visions in the Spanish Colonial World* (New Haven: Yale University Press, 2012), 192.

10 Mark Santiago, *The Red Captain: The Life of Hugo O'Conor, Commandant Inspector of the Internal Provinces of New Spain*, Museum Monograph 9 (Tucson: Arizona Historical Society, 1994).

11 Donald C. Cutter, *The Defense of Northern New Spain: Hugo O'Conor's Report to Teodoro de Croix, July 22, 1777* (Dallas: Southern Methodist University Press, 1994).

12 Margaret Kenny Kress, Fray Gaspar José de Solís and Mattie Austin Hatcher: "Diary of a Visit of Inspection of the Texas Missions Made by Fray Gaspar José de Solís," *Southern Historical Quarterly* 1 (1931): 28–76.

13 Carolyn Kidder Carr, ed. *Spain and the United States in the Age of Independence, 1763–1848* (Madrid: Julio Soto Impressor, n.d.), 258.

14 Marion Oettinger, Jr., ed., *Retratos: 2000 Years of Latin American Portraiture* (New Haven: Yale University Press, 2004).

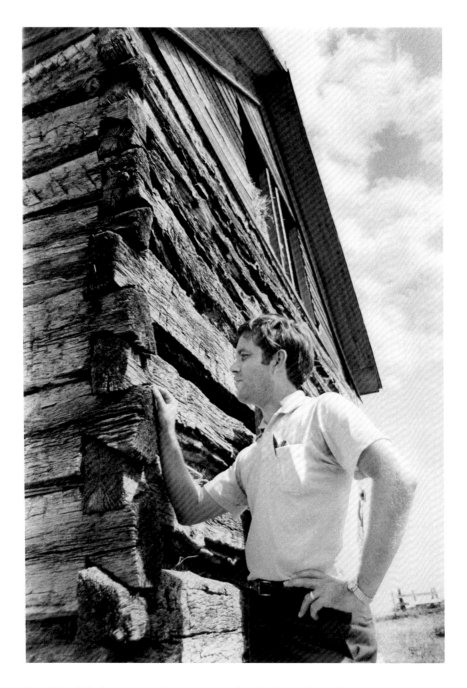

Fig. 1. Terry G. Jordan examining the corner notching of a cabin, Denton County No. 29,
the Texas Log Cabin Register, the Terry Jordan Collection, University of North Texas Special Collections.

House-Proud in Texas:
The Struggle for a Proper Pioneer Home

Evelyn Montgomery

"It was Joel that covered the cabin with his home."[1] This enigmatic statement was once easily understood by any western pioneer in a forested region where logs were available to harvest. In 1830 Jesse Cartwright built a log cabin in Fort Bend County to provide basic, minimal housing. In 1870 Joel McCreary built a better house around it, and the cabin moved from rough pioneer necessity to fashion, comfort, and respectability. The movement from log cabin living to a home that better fulfilled period expectations was a recognized marker of success on the frontier. Most Americans saw the home as a representation of financial achievement and community standing. Achieving such a home on the frontier was quite a challenge.

We have evidence of how Texas pioneers met that challenge. Some comes to us in writings left behind by those pioneers, but as historians so often bemoan, diarists and memoir writers of old never wrote enough to satisfy researchers' needs. Thanks to the work of Dr. Terry Jordan, we can also study the important evidence found in the structures themselves. Dr. Jordan was a geography professor at the University of North Texas and later at the University of Texas at Austin, and the author of *Texas Log Buildings: A Folk Architecture*, published in 1978 (fig. 1).[2]

For his systematic analysis of the log construction techniques used by Texans, Dr. Jordan required data. He collected it in the Texas Log Cabin Register, a vast volunteer effort to document existing structures throughout the state. His students wrote papers about cabins in their hometowns, often family legacies, using information unavailable to any other historian. Dr. Jordan created a questionnaire any amateur could use to professionally document the construction of a cabin (fig. 2). The Texas Historical Commission asked the county commissioners to scour the woods for subjects and submit the forms along with photographs. Newspapers enlisted readers to do the same. They documented 800 cabins, some hidden away in isolated areas that only the older local residents knew existed. Many of them had been abandoned and were tilting, falling, or had already collapsed. Those exist now only in the Register.

The goal of Dr. Jordan's research was to trace the origins of Texas settlers by documenting their cabin-building practices. A key feature of any cabin's construction

Burnet Co. no. 5

TEXAS LOG CABIN REGISTER

under the supervision of
Prof. Terry G. Jordan
Dept. of Geography
North Texas State University
Denton, Texas 76203

Please fill out as completely as possible, but fragmentary reports are also very helpful. Answers to some of the questions may no longer be available.

County of location ___Burnet___
 original on South Gabriel present
Specific location 3½ mi. SW Bertram(Hi.243... ½ mi. N bertram Hi. 1174
 (if cabin has been moved, give both original and present location)

Name of Builder ~~Carpenter~~

Place of origin of builder _____

Is the cabin presently occupied? ___yes___

Present condition of cabin _Good shapp...restored_

Approximate date of construction ~~Estimated 1830(Probably much too early)~~
(More likely to be 1860 and the Civil War aftermath)..His. Survey Comm.
Type of corner notch (see attached illustration) ✓ half- dovetal notch
 (attach photo of notching if possible)

Logs are (circle one) (1.) hewn (squared) 2. round 3. half-round

Type of wood used ___oak___

Type of chimney (circle one) (1.) stone 2. brick 3. cat (mud and stick)
 1½- story doghot house

Floor plan (sketch, showing approximate dimensions)

Name and address of person making this report Sigman W. Hayes, MD
 Rt. 2 Box 279
 Bertram, Texas 78605
 (NTSTC Class '3
 '32

If possible, attach a photograph of the cabin.

Note: Local "historian" Mr. Bill Turner, says during Texas Revolution after the Alamo, neighbors desigated this house as a neighborhood fort, if the Mrxicans came.

is the shape of the notches cut into interlocking logs at each corner, holding them together. There are several notch types, and the examples in the Register revealed which ones were commonly used in which parts of Texas. He argued that each pioneer cabin builder arrived with construction knowledge local to his place of origin.

Dr. Jordan's investigation focused on classifying people who came from the Upper South—Kentucky, Missouri, and Tennessee, and those who came from the Lower South—the Gulf Coast states. He was working in the tradition of cultural geography, tracing the movement of people by the artifacts they created. He was able to map the areas reflecting what he called "upper southerness," concentrated in north central Texas and the cross-timbers region. A more sophisticated form of notching was used there than what southerners brought to east and southeast Texas.

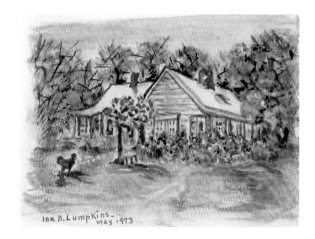

Left:
Fig. 2. Log cabin documentation form submitted by a local researcher to the Register, with corrections in red by Dr. Jordan, Burnet County No. 5, the Terry Jordan Collection, University of North Texas Special Collections.

Right:
Fig. 3. Ida B. Lupkins, watercolor depiction of Ellis County No. 2, the Texas Log Cabin Register, the Terry Jordan Collection, University of North Texas Special Collections.

Because his focus was so intense, it can be challenging to find evidence in the register to illuminate the issue of how cabins grew and changed. He did address the issue of cabin growth in his book, and the popular perceptions of cabins were addressed in Linda Lavender's subsequent exhibition and book using his material.[3] Dr. Jordan specifically asked for information about notching, and that is what people sent him. For some cabins, the only picture submitted is of the notching, with no indication of the overall shape or plan. The records range in length and completeness. Some include vast research. One informant sent him a charming watercolor painting with the history of the cabin written on the back (fig. 3). With careful research they did reveal information beyond his targeted request.

How did the cabin fall short of domestic expectations? The problems went beyond physical failings and impediments to comfort, though those were notable. The period of American settlement in Texas coincided with the Victorian era. Victorian expectations of proper behavior and morality were strict, and it was widely accepted that the appearance and condition of the home could broadcast its inhabitants' conformity to those standards, or lack thereof.

These impossible standards included a complex system of etiquette and mutual critical observation of the level of taste shown in each other's clothing and home furnishings. Cleanliness, reading, and education were part of a respectable domestic life, along with the study of music and art, and, for ladies, industriously plying their needle at craftwork. Moral expectations were high. Good people did not discuss or think about sexuality. All natural functions and bodily activities were to be hidden, as if they did not exist. Children's purity was sacred, and they must not be exposed to strangers who might be coarse, poorly spoken, or dirty. It was increasingly

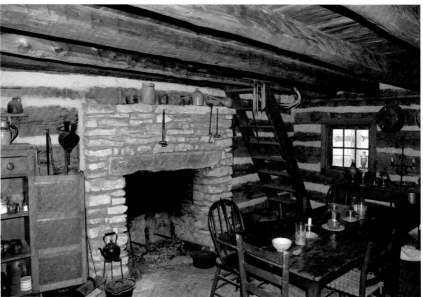

Top to bottom:

Fig. 4. William Brown Miller's cabin, built 1846, Dallas County No. 3, the Texas Log Cabin Register, Dallas Heritage Village.

Fig. 5. Interior of the Miller cabin as furnished at Dallas Heritage Village, showing the multiple uses for the main room, Dallas Heritage Village.

important to have separate bedrooms for girls and boys, and rooms in the house for public activity like entertaining, with more private areas for family activities. Most of this was not possible in a one-room cabin. Since Victorians were quick to judge each other, the historical record offers many examples of careless cabin criticism by travelers and frontier newcomers. A Dallas immigrant in 1844 had high expectations. When he arrived, he reported his disappointment to relatives back home: "but the town—where was it?"[4] Dallas was nothing but a collection of cabins.

Fifteen years earlier and much further south, Noah Smithwick arrived in Dewitt's Colony at a settlement on the Lavaca River. He too saw his high expectations wither. On his journey "the beautiful rose color that tinged my visions of Texas . . . paled with each succeeding step," and he harshly judged the colonists' cabins as "absolutely devoid of comfort."[5] Such critics often added comments about the haggard appearance of the resident ladies and the dirty bare feet of the children. Frederick Law Olmsted charitably referred to one of his hostesses as a "bold-faced but otherwise good enough-looking woman."[6]

American settlement in Texas also coincided with heightening expectations for the size and stylishness of houses. News of such fashions could travel to the frontier in publications such as Godey's Lady's Book. The necessary materials and specialized craftsmen were not, however, available on the early frontier, so an ideal house was not possible. Instead of pursuing style, new frontier residents dealt with the cabin's lack of three key domestic elements: windows, floors, and interior walls. Passing critics often focused on these shortcomings, which resulted from decisions made by the cabin builders, usually men. Critics missed the creative ways women worked to ameliorate the faults.

Cabins had few windows because each wall opening weakened the structure and cost too much labor. Also, window glass was rarely available on the frontier. Windows were the main source of light for everyday tasks and valued activities like sewing or reading. Leaving the door open was the common solution, but unfortunately allowed cold winds and roaming farm animals into the home.

A proper housewife could do little about that situation, but she could lessen the effects of her inadequate floors. A dirt floor can be wetted, tamped down, and swept daily until it becomes more solid. Then the wife could apply her skills in sewing and frugal fabric saving to make rag rugs to cover the dirt. The lady lucky enough to have a rude puncheon floor—round logs split down the middle and laid with the curved side down—found it uneven and splintery. Hard work solved that. Kate James of Garland recalls that it took endless scrubbing with hot water, ashes and cornhusks to make the floor smooth.[7] The greatest challenge was the lack of privacy. Lucy Erath

recalled that one room harbored the whole family and all visitors. It was the kitchen, dining area, and bedroom for everybody. Hanging quilts as privacy curtains was one of the few solutions available until additional rooms could be added.

The proper home was increasingly defined by the inclusion of attractive household goods produced in factories, displacing homemade objects. They confirmed the family's taste. Few such goods made it to the frontier home, and they were cherished. Young Polley Rowlins wrote relatives back home that her mother's dishes survived the trip to Texas, but they lost the clock.[8] Mrs. Isaac Van Zandt wrote, "To the first wedding to which I was invited in Texas I carried the dress in which the bride was married, and the plates from which we ate the wedding dinner."[9] Pioneers could pool their treasures to create a special event.

Frontier children understood the different degrees of respectable home life among their neighbors. Edward Everett Dale was not shy about that issue in his charmingly illustrated book, *The Cross Timbers, Memories of a North Texas Boyhood*. He said rural families did not have dining rooms, which were often seen as an important social marker. Tables were too small to accommodate the family and visitors, and the chairs never matched. Yet social occasions were properly distinguished from family meals, when the table was covered with a utilitarian oilcloth for easy cleaning. Guests were served on a nice tablecloth, while the children were exiled outdoors to await their turn at the table.

Children learned to judge class differences. Dale wrote: "it must be confessed that there was little relationship between the size of a family and that of its living quarters. The Clarks . . . had five children but lived for some years in a crude, two-room log house before adding another room at a cost of forty dollars!"[10] The author's own father had added a third room much sooner. The more respectable Taylor family was distinguished by having "a big two-story white house with a wide porch in front and above it an upper porch."[11]

Dr. Jordan himself investigated the cabin designated in the Register as Dallas County Number 3, the first home of pioneer William Brown Miller (fig. 4). Miller's initial cabin and the fashionable house that followed it represent an ideal upward mobility that Edward Dale would have applauded.

Mr. Miller arrived in Dallas in 1846, acquired a great deal of land, became known for breeding fine livestock, and found successful pioneering to be quite lucrative. He brought his family, including his second wife, Minerva Miller, his adult son, Crill, and several children. He also brought three enslaved couples, and those men labored with Crill to build the cabin. The cabin's construction suggests that they knew how to build with logs, but were not highly skilled.

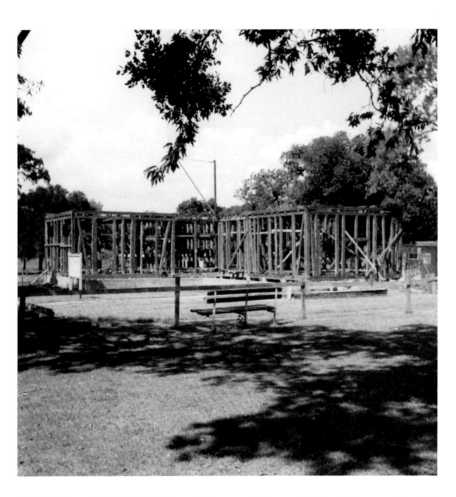

Fig. 6. Millermore, built 1855–61, the heavy timber structural frame revealed when the house was dismantled in 1968 to move to Dallas Heritage Village (then called Old City Park), Dallas Heritage Village.

Fig. 7. The parlor in Millermore, as furnished at Dallas Heritage Village.

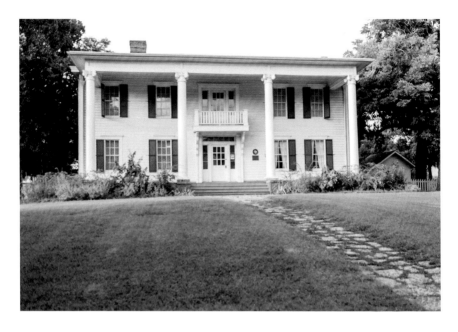

Fig. 8. Millermore exterior, Dallas Heritage Village.

The original room measured 18 by 20 feet and, as was the norm, enclosed all family activities (fig. 5). It did have one glass window. The first addition Dr. Jordan identified was the self-explanatory room-on-the-porch. With a roof already in place, enclosing half of the porch was simple. Dr. Jordan identified the next addition, a long room on one side, as a dining room. Although a dining room was a valuable marker of polite society, it is more likely the senior Millers used it for a private bedroom.

By 1855 Mr. Miller acquired such wealth that he could begin construction of a fine home. While the internal structure was made from local oak trees, like those used for the cabin, they were shaped into a complex framework (fig. 6). Until the house was relocated to Dallas Heritage Village in 1968, that frame was hidden behind milled siding hauled from Jefferson, one hundred miles away. Large windows were imported from New Orleans. The house had finished woodwork, a parlor, and a dining room. Each of those rooms was big enough to hold the entire original cabin. The parlor was an expensively furnished room for public entertaining (fig. 7). The family sitting room, dining room and all three bedrooms were equally spacious. Mr. Miller's office had a separate entrance, to keep his business visitors away from the family. The front door opened to a wide center hall where guests could be

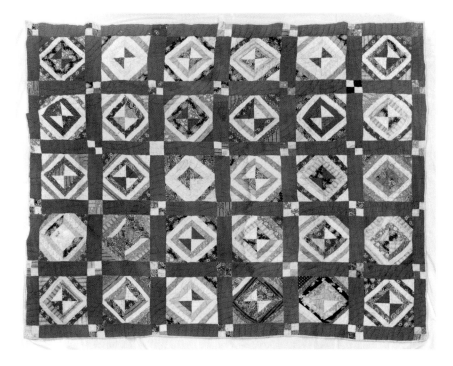

Fig. 9. Minerva Barnes Miller, **Quilt**, *c. 1850, Dallas Heritage Village.*

received and be impressed by the graceful staircase. The hall was flanked by public rooms, and the separate bedrooms for parents, boys, and girls were upstairs. This arrangement was the long-established ideal of a fine home. With its popular, though almost outdated Greek Revival style, the house was exactly the kind of symbol of success a man on the frontier wanted to achieve (fig. 8).[12]

Minerva Miller must have been excited at the new domestic prospect, but she did not live to see the house's completion. Her death was followed by that of her husband's closest friend, who left behind a young widow with an inheritance to rival even Mr. Miller's wealth. Emma Dewey Miller would be the first lady of the grand home, filling it with fine furnishings and dishes brought to Texas at great cost.

The difference between the cabin lifestyle of Minerva and Emma's life in Millermore is reflected in their quilt art. Minerva's is made of cotton scraps, a warm cover for cold cabin nights (fig. 9). Stained and torn, it was well used. Emma's is made of tiny pieces of silk, probably purchased for this work of art (fig. 10). It was never intended for use, but for display.

Fig. 10. Emma Dewey Miller,
Quilt Top, *c. 1880, Dallas*
Heritage Village.

Below:
Fig. 11. Grayson County No. 2, as revealed when surrounding rooms were removed. Denison Herald, February 17, 1974, the Texas Log Cabin Register, the Terry Jordan Collection, University of North Texas Special Collections.

Right:
Fig. 12. Eddleman house, Pilot Grove, Texas.

Century-Old Log House Found
Inside House Being Torn Down

FINK — When Joe Hughston planned on doing a little building around his home he got an unexpected assist in an offer to raze an old house for its material.

"I checked the old house and found the lumber in excellent condition and jumped at the chance," said the Pottsboro vocational school official.

But what Hughston didn't expect was a century-old hand-hewn log house right in the center of the building he was razing.

"The logs had been covered up with the siding on the outside and with all wall paper or wall board on the inside," Hughston explained. "I really was amazed when I found the old log cabin."

The cabin was a one-room affair with a fireplace. It was built of hand-hewn oak that was in what Hughston called "near-perfect condition."

Hughston said the house he tore down was ~~built~~ by Pete Christman, a German native who came to this country around the turn of the century. He had a brother who lived in Denison and who had first a bakery, and later a laundry.

W. L. Moon, who lives across the road from the Christmans, recalled that, Christman had told him the story of arriving here and buying the land with the log cabin on it "just to have a roof over my head." He then added the four rooms to the original cabin himself.

Moon recalled one of Christman's favorite stories was about seeing a neighbor out plowing one day shortly after he arrived here. He went over to introduce himself and learned that the neighbor, Anton Brockman

came from the sametown in Germany even though he was a White Russian.

Hughston said apparently the log cabin was built by some of the early settlers in the area. "It is pretty hard to pinpoint the actual time, but somewhere between 1850 and 1860 would be a pretty good guess," he said.

Hughston calculates that there are some pretty good old antique items around in the ground. But he said he probably would ask the owner, Billy Harrison, to just move in his bulldozer and level the area.

The old house is located just across east from the

Tanglewood-on-Texoma airstrip.

Hughston said some young boys who had helped him with razing the building had found one Indian head penny "and I don't recall its date" plus an 1871 quarter.

There are some old wooden spoke wagon wheels out in the back, too.

In the front yard there is a gnarled cedar tree that easily is much older than the house. "I'm sure that old cedar was a pretty sizeable tree when it looked down at the time the log cabin was built," said Hughston.

There is a rock storm-

cellar in the rear of the house and some of the Christman's relatives have indicated that there was a wine cellar on the west side of the house at one time. But whether the wine was made from fruit or grapes was not discovered.

Hughston plans to contact George Ward, who hauled in an old sawmill from East Texas and who is sawing up lumber to build his own home. about the oak logs.

"I think with his saw mill, he could find them most handy. They should make a beautiful floor," Hughston added.

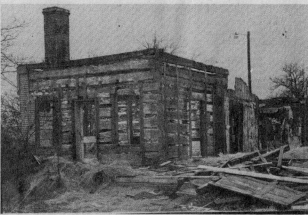

from The Denison Herald (Sunday, Feb. 17, 1974, section C, p. 1)

THIS OLD HOUSE — The new part of the old house was well on its way down before Joe Hughston discovered this log cabin in the center of the west side of the house.

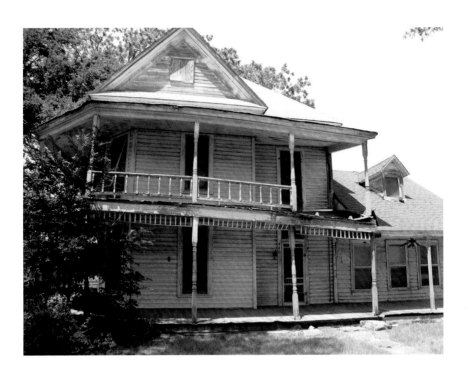

This homebuilding story was the ideal, but rarely the reality for ambitious pioneers; most were prudent with their resources. Charles B. Moore, a Denton County settler who kept a diary of his daily work, practiced frontier frugality. When he was ready to give his family a new brick house, he included a few luxuries, such as wallpaper. He built a two-story house with bedrooms separated upstairs from the public rooms below. The public rooms were ceiled, that is, the ceiling finished with wood for a nice appearance. That would have been wasteful upstairs, where the public never went. His first house had one window, which he removed and installed in the new house, it being too valuable a commodity to waste. He reused the old roof shingles, so that one night before the new house was finished, rain poured into his bedroom while he slept.[13]

A more resourceful and often more gradual solution was to cover the original cabin with new construction. Grayson County No. 2 in the Register was so well hidden in this manner that residents were unaware of the log room until the house was being demolished in 1974 (fig. 11).

The Eddleman family in Pilot Point effectively built a standard home around a single room cabin (fig. 12). Plastered inside and covered with siding outside,

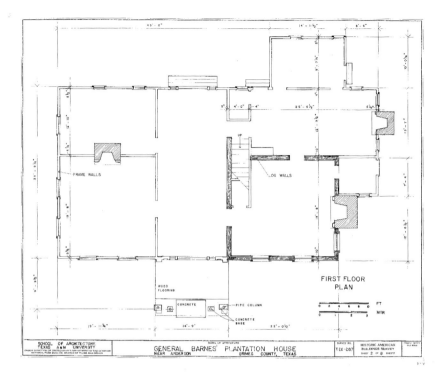

Fig. 13. James Barnes house, first floor plan, Historic American Building Survey Collection, Prints and Photographs Division, Library of Congress, HABS TEX,93-AND.V,2 (sheet 2 of 8).

the cabin formed the single-story portion on the right. It was entered through a center hall that served as entry, stairway location, and fulfillment of the Victorian expectation for the transition zone where friends and strangers were sorted, and guided to public or family areas. The formal parlor on the other side of the hall and the bedrooms above were new. From the exterior, the original log room might be mistaken for haphazard addition.[14] The house was eventually dressed in fancy Victorian ornament.

Many Eddleman family members immigrated to early Denton County and one, David, left an autobiography. He opens with the statement: "I began life when I was very young."[15] They came from the Upper South, where he said they had lived in a cabin where they were quite comfortable. Once, in Texas, he watched a neighbor manufacture homemade bricks and use hand saws to shape trees into respectable lumber for a fine house. "My father also built a house that year," he wrote, "but it was not so fine. It was built of hewn logs."[16]

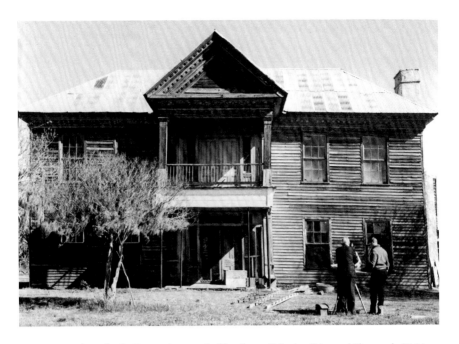

Fig. 14. Barnes house facade, Historic American Building Survey Collection, Prints and Photographs Division, Library of Congress, HABS TEX,93-AND.V,2—1.

Near the town of Anderson, in Grimes County, James Barnes thoroughly buried a two-story, single pen cabin (fig. 13). The dark walls on the plan signify log construction; the other walls are frame construction. The Barnes house presents a more complete center-hall arrangement than that of the Eddleman house (fig. 14). It is fully symmetrical on the outside, with the centrality emphasized by the projecting and heavily decorated entry. The house appears more as if it were built at one time, according to a classic plan.

Structural realities made it difficult to smoothly incorporate a cabin without leaving a hint of the logs below. To build cabin walls, workers had to raise heavy logs into place, which was difficult and dangerous. Understandably, walls were often built to a minimal height, so rooms had low ceilings. Fashion and cooling needs during a hot Texas summer demanded tall rooms. A cabin encased in even the finest house could reveal its origins when a tall gentleman's head brushed the ceiling. Log wall construction is also limited to enclosing square and rectangular spaces with minimal openings. The length of each room depended on the height of available trees. Two log rooms could be joined directly together, with skill and effort, but it was much easier to give each a separate exterior entrance.

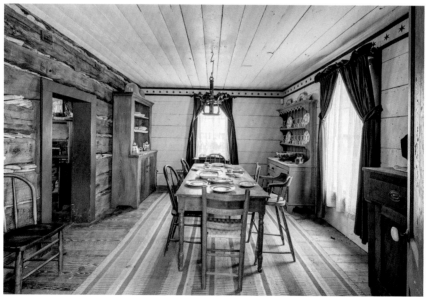

Top to bottom:

Fig. 15. Morehead-Gano house, as restored at Dallas Heritage Village.

Fig. 16. Dining room in the Morehead-Gano house, as furnished and finished by Dallas Heritage Village.

The best accommodation to this unusual domestic situation was the dogtrot house. The two rooms with their separate entrances were moved further apart and the space in between was covered with a porch. Properly oriented to catch breezes, this outdoor room, through which dogs could trot, offered summer comfort. Residents used that space for working, dining, and even sleeping. As an entrance to the home, it mimicked the form and use of the center hall in houses.

Dogtrot houses were easily expanded into larger homes as the family prospered. Thanks to Dr. Jordan's close inspection, the exact growth pattern of one such house is known. The Morehead-Gano Cabin, Tarrant County Number 9, was originally located near Grapevine before it was moved to Dallas Heritage Village (fig. 15). James Tracy Morehead was the second owner. General Richard M. Gano spent little time at the house because of his Civil War participation, but he is the best known of the house's six owners. The original builder, Andrew Anderson, came from Missouri in 1845, presumably carrying the folk culture of the Upper South.

When Mr. Morehead's family arrived at their newly purchased home in 1852, his daughter's first impression upon seeing her new home was negative: "[What] a dreary looking place it was—there were two log cabins, about fifteen feet apart which was covered, but not floored."[17]

Because log cabins are usually moved by disassembling them, Dr. Jordan had a unique opportunity to read the cabin parts during the move to Dallas Heritage Village, and to understand all the changes made over time. Many were done by Mr. Morehead and surely pleased his daughter. He gave the house a floor, and added two rooms on the back. One is a rare example of a builder exerting the effort to directly connect two log pens. It created a dining room, with all the associated civilization and propriety (fig. 16). The other was added later, when milled lumber became available. Two rooms upstairs brought the total to six, offering the opportunity for separate bedrooms.[18]

That was the house that General Gano bought for his wife, who was told by a neighbor that it was a fine house because of that dining room, and that Dr. Jordan used in his book to illustrate that the affluent "man's log home was larger, taller, and better made than his poorer cultural kinsman's."[19] Affluence looked different at this house than at Millermore, thirty miles away, but Millermore was the exception, and the improved dogtrot form was more common.

Those extensive improvements committed owners to maintain this house rather than build new, which may have been a common impetus for continued growth and the addition of adornment. Later owners enclosed the dogtrot to become a true

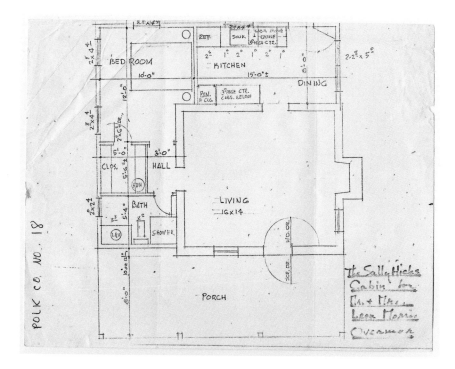

Fig. 17. Plan of Polk County No. 18 with additions, the Texas Log Cabin Register, courtesy of the Terry Jordan Collection, University of North Texas Special Collections.

center hall, and covered the logs with siding. They even added a Victorian wrap-around porch. The house's log origins became unrecognizable.

Dr. Jordan agreed with museum leaders that the relocated house should be returned to its appearance during the Gano family's period of residence, circa 1860. That decision was made in support of the museum's goals of depicting daily life for an early Dallas family on a farm. The cabin is presented at the midpoint of its transition from a cabin that could have been abandoned for a home of standard construction and shape, to one that disappeared under an outer disguise.

His evaluation of this cabin reflected his understanding of the dogtrot in the pre–Civil War Upper South influenced Blackland Prairie and Eastern Cross Timbers regions. He argued that the form of the dogtrot was rare in Missouri, Tennessee, and Kentucky. To build one in Texas, instead of a simpler single pen cabin, was the mark of extra wealth on a new frontier. Noah Smithwick concurred. Young men were proud to have a dogtrot. Its size and degree of comfort spoke of the builder's material resources and capacity for hard work, perhaps enough to raise his value in the

Fig. 18. Exterior of Denton County No. 4, with exposed log construction, stone, horizontal siding, wall shingles, and scalloped trim.

marriage market. Smithwick was recalling an earlier and more southern frontier, the De Witt Colony, but Dr. Jordan's careful analysis revealed that area's early population was sixty percent Upper South in origin.

Dr. Jordan praised the Morehead-Gano cabin as "the most impressive log structure I have seen in the [Tarrant, Denton, and Cooke] county area."[20] It size and low upper story marked it as that of not just a well-to-do but a "better-to-do" farmer, despite the use of simple square notches on the upper level. He called these easily cut but unstable notches "degenerate." They were associated with the folk culture of the Lower South. The distinction between upper and lower southern culture was the focus of much of his work.

As early as 1966 Dr. Jordan argued against what he saw as accepted history that Texas was settled by those from the Lower South and reflected that culture. In an article that year, he translated census information about pioneer origins into maps detailing the origin of early pioneers to Texas counties. The settlement patterns were clear. The Lower South culture was dominant only in East Texas. His own home region around Dallas was firmly upper southern. He was not yet discussing corner notching. The cultural differences were economic and political. They focused on

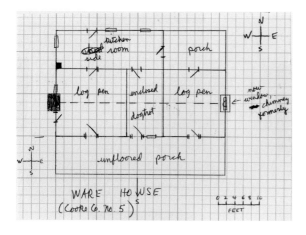

Fig. 19. Plan of Cooke County No. 5, a dogtrot cabin with later additions, demonstrating the naturally orderly pattern the dogtrot plan inspired, the Texas Log Cabin Register, courtesy of the Terry Jordan Collection, University of North Texas Special Collections.

agricultural practices, with the South preferring cotton to the northern farmer's wheat, and pulling the plow with mules rather than northern horses. Other key differences were slave ownership and support of joining the Confederacy. He was certainly correct that those markers of southern affiliation were weaker in North Texas, but both William Brown Miller and Richard M. Gano owned slaves and supported the Confederacy. He hinted at the end of that article that his research interests might spread into cultural areas, such as folk language and buildings.[21] In his later work he studied not only log cabins but also cemeteries and rural dialects.

Though he was an early leader in the study of log construction, a body of parallel and continuing work took place. Some challenged his conclusions about the small role of the dogtrot in the Upper South. Lyn Allison Yeager found dogtrots in all stages of development in Warren County, Kentucky. With extensive photographs and corner notching drawings, her book was locally published in Bowling Green. Such parallel research would have been difficult for Dr. Jordan to access while he was formulating his ideas. In Eastern Tennessee, John Morgan later followed Dr. Jordan's interpretive methods to identify local patterns. The dogtrot was not rare in the counties he studied. He identified a local growth pattern into a full two-story form, one room deep, and quite different from the Morehead-Gano cabin.

If the elevated image of the dogtrot depended on its impressive size on the early frontier, that was not a feature that could last. Pride in belongings tends to be relative, and what once seemed big starts to feel small as the family grows and surrounding standards change. Dr. Jordan's evaluation of the Morehead-Gano cabin focused on the period before the Civil War, which interrupted the ongoing process of transforming it to a house that was not visibly of log construction. By the end

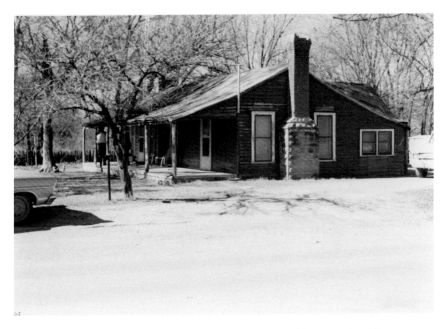

Fig. 20. Palo Pinto County No. 3, the Texas Log Cabin Register, courtesy of the Terry Jordan Collection, University of North Texas Special Collections.

of the war, north central Texas was moving beyond log construction and "such log construction as occurred in this area would have been confined to the lower socio-economic classes. The Morehead-Gano house does not reflect that class."[22] And so it reflects upper southern progress. In contrast, new log construction continued in East Texas until the 1930s. Dr. Jordan's work clearly privileges fine *early* log construction as positive culturally, but later use as a negative.

The way in which a dogtrot was created also marked status. His careful study of dogtrot pen proportions and original door locations allowed him to determine that the first two pens of the Morehead-Gano dogtrot were built at the same time. Only this could mark a dogtrot as an early symbol of wealth. Where a dogtrot was created by the much later addition of the second pen, that represented slow rather than early success. Despite the best intentions of every historian to be unbiased, Dr. Jordan allowed a certain preference for the culture of the Upper South to invade his work. He declared the East Cross Timbers "a western outpost of a remarkably pure backwoods upper southern subculture," and found much to praise in that folk tradition.[23]

Log construction and the folk cultures that guided it enjoyed only a short reign in Texas. The larger national culture gained power. Easy transportation, the constant movement of peoples, and mass publishing spread ideas like Victorian domestic

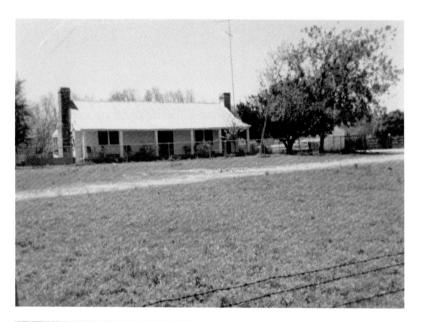

Top to bottom:
Fig. 21. Burnet County No. 8, the Texas Log Cabin Register, courtesy of the Terry Jordan Collection, University of North Texas Special Collections.

Fig. 22. Grimes County No. 6, the Texas Log Cabin Register, courtesy of the Terry Jordan Collection, University of North Texas Special Collections.

expectations to previously isolated settlements. Folk culture faded. The importance of regional origin in home design faded. Dr. Jordan's specific interests focused on the initial phases of what he called the "log culture complex," not the later ones.[24]

We must not make the mistake of overstating the force of Victorian-era culture on frontier domestic decisions, though it was powerful. A bigger, more comfortable house was desirable in and of itself. Anything that represented growth and improvement represented industriousness and success. Not even Victorians could fail to balance imagistic social concerns with the practical needs of everyday life.

In the usual growth pattern of the single-pen cabin, we see practical building more than stylized architecture. Their growth appears organic and gradual. Needed rooms were added where there was an empty space that could be made into a room by adding the fewest number of walls. For example, Polk County No. 18 was originally a single-pen cabin; its additions maintained a generally square shape for the house, but the interior plan is not ideal (fig. 17). As the building matured along with the needs of the residents, there was little opportunity to plan for an effective entry hall, or to design an artistic facade. Denton County No. 4 shows no effort to hide material changes on later expansions, yet the builder did add some random decorative shingles and trim (fig. 18). Such a house has a beauty, but not one likely to inspire architectural copycats.

An advantage of the dogtrot was that it offered an established organization that made it easier for the vernacular builder to produce a pleasing form for the growing house. Its original layout suggested an orderly route for expansion that led the builder to produce a pleasing symmetry (fig. 19). Though some dogtrots grew sideways by the addition of more breezeways and more pens, most followed the pattern of the Morehead-Gano cabin. The house grew backward along the guiding spine of the dogtrot space. The first rear additions might be temporary lean-to rooms, later replaced by permanent construction. Cladding, enclosure of the breezeway, and the addition of a front porch followed. This similar pattern of growth produced similar results. The dogtrot cabin became the recognizable form of a small ranch house. It is not the ranch house of arid West Texas, with stone or adobe as the material that defined its shape. The dogtrot ranch's size and shape was defined by the forest that was cut down to make it, the trees hidden in its walls. The long, low dogtrot ranch fits beautifully on the Texas landscape. Tradition combined with progress created a new form, a Texas form that crossed the boundaries of Upper or Middle South origins.

In the 1930s, Texas architects actively pursued inspiration for a native Texas architecture. The leaders included David R. Williams and O'Neil Ford, both of

Fig. 23. Nacogdoches County No. 13, the Texas Log Cabin Register, courtesy of the Terry Jordan Collection, University of North Texas Special Collections.

whom had associations with Dallas. Their field research into historic house examples concentrated on the Hill Country and the original colonial areas of Texas, and they achieved their goal of translating what they saw into a new regional style. It is a pity that they did not expend as much effort closer to home, or have the benefit of the Log Cabin Register. They may have deprived their art of the influence of the evolved dogtrot ranch.

Those dogtrots that grew and changed evolved into a similar aesthetic as that seen in the mature Morehead-Gano cabin. The roof of the long front porch is a continuation of the main roof, with perhaps a slight bend where they meet, as seen on Palo Pinto No. 3 (fig. 20). Dr. Jordan's observations about the differences between dogtrots where the two pens were built at the same time and those that were expansions seems to produce lingering effects. Dogtrot ranches that grew from the first type would tend to produce a symmetrical facade with the main entrance centered, where the dogtrot once opened. The chimneys centered on each end served the two original cabins (figs. 21–22). Burnett County No. 8 and Grimes County No. 6 look like this, and the latter has a low upper story lit by windows on either side of the end chimney. Nacogdoches County No. 13 has small upper windows just under the roof, like the Morehead-Gano house (fig. 23).

In contrast, Freestone County No. 5 and Red River County No. 2 have less neatly arranged facade openings, perhaps because of more gradual original lateral

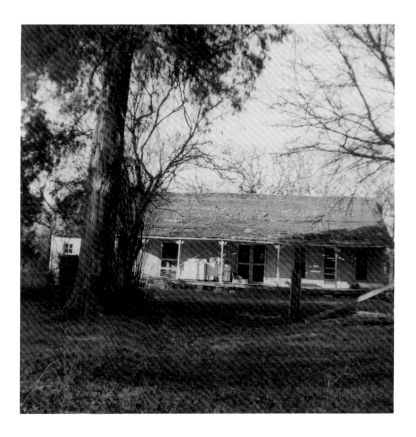

Fig. 24. Freestone County No. 5, the Texas Log Cabin Register, courtesy of the Terry Jordan Collection, University of North Texas Special Collections.

growth (figs. 24–25). The arrangement is hidden by the low porch roof and its deep shadows. The chimney in the middle of the second example probably marks the edge of the first pen built. These anomalies do not really detract from the similarities in this sample of images drawn from the Register. Dogtrot ranches are a recognizable house form.

The pioneer's pursuit of a large and respectable home took many paths to fulfillment. A cabin was the beginning and led to many options. Dr. Terry Jordan's theories, writings, and the heroic compilation of the Texas Log Cabin Register can similarly continue to inform new inquiry, as all good historical research should.

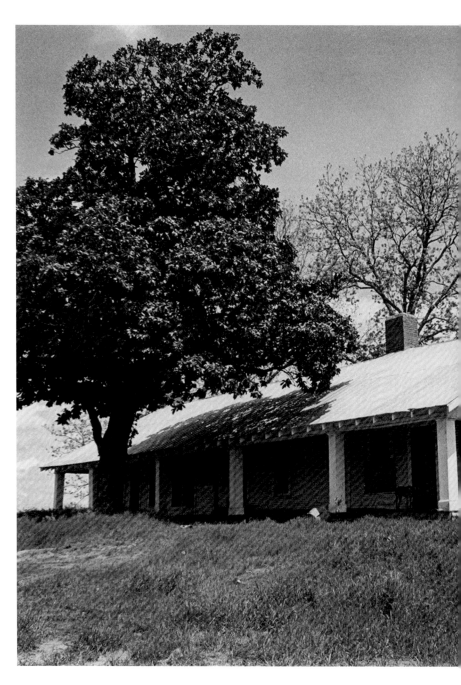

Fig. 25. Red River County No. 2, the Texas Log Cabin Register, courtesy of the Terry Jordan Collection, University of North Texas Special Collections.

Notes

1 Fort Bend Co. No. 1, in the Texas Log Cabin Register, Terry Jordan Collection, University of North Texas Special Collections.

2 Dr. Jordan reserved the word "cabin" for poorly built structures, calling more finished ones "log houses." The present article uses "cabin" for all domestic structures made of logs, as that word is more commonly associated with the image of the structure.

3 Linda Lavender, Cirrus Bonneau, Eva Dickson, *Dog Trots & Mud Cats: The Texas Log House* (Denton, TX: North Texas State University Press, 1979) and its companion exhibition were a team production headed by archivist Linda Lavender. Dr. Jordan served on the advisory council and wrote the preface.

4 John B. Billingsley, "A Trip to Texas," edited by R. L. and Pauline Jones, *Texana* 7, no. 3 (1969): 203–4.

5 Noah Smithwick, *The Evolution of a State; or, Recollections of Old Texas Days* (1900; repr. Austin: Steck-Vaughn, 1968), 14.

6 Frederick Law Olmsted, *A Journey Through Texas: Or, a Saddle-Trip on the Southwestern Frontier*, (1857; repr., Austin: University of Texas Press, 1978), 48.

7 Michael R. Hayslip, ed., *Sketches of Kate James: Dallas County Pioneer* (Garland, TX: Garland Landmark Society, 2009), 21.

8 Kathryn Smith Miller, *Polly Rawlins Miller: A Biography* (Dallas: Eades and Associates, 1973), 3.

9 Frances Cooke Lipscomb, *Reminiscences of Frances Cooke Lipscomb*, quoted in Joseph William Schmitz, Thus They Lived: Social Life in the Republic of Texas (San Antonio: Naylor, 1935), 23.

10 Edward Everett Dale, *The Cross Timbers: Memories of a North Texas Boyhood* (Austin: University of Texas Press, 1966), 12.

11 Dale, *The Cross Timbers*, 31.

12 Information about the Miller family is found not only in the extant structures, but also in extensive writings by William and Emma's granddaughter, Evelyn Miller Crowley. She wrote family histories and genealogical reports now housed in the archives of the Dallas County Heritage Society at Dallas Heritage Village. She also published the autobiographical *Texas Childhood* (Dallas: Kaleidograph Press, 1941).

13 These construction details are from the transcript of his diary, for the latter half of 1883. Charles B. Moore Collection, 1797-2003, University of North Texas Special Collections.

14 The author visited this structure in 2015 at the invitation of city officials considering moving it to a museum. The original cabin is pictured in Jay Melugin, *Pilot Point* (Charleston: Arcadia, 2009). The addition was built in the 1880s.

15 David J. Eddleman, "Autobiography of the [illegible] by David J. Eddleman," David Jones Eddleman Collection, University of North Texas Special Collections, Denton, TX, 1.

16 Eddleman, "Autobiography," 7.

17 This is part of Mattie Morehead's extensive commentary on her journey to Grapevine and their new home, recorded in a privately held diary and reported in Weechie Yates Estill, *Grapevine Recollections* (self-published, 1965), 15.

18 The growth of the house and the experiences of the families that lived there are preserved in the archives of the Dallas County Heritage Society. Terry G. Jordan's report "Evaluation of the Morehead-Gano Log House, Grapevine Prairie, Tarrant Co., Texas," is in the file for Tarrant County No. 9 in the Texas Log Cabin Register at the University of North Texas Special Collections. See also Doyle S. Granberry, "Mary Anderson Lived Here," *The Record* (Dallas Archeological Society) 33, no. 1 (1977), 2–8.

19 Terry G. Jordan, *Texas Log Buildings: A Folk Architecture* (Austin: University of Texas Press, 1978), 18.

20 Jordan, "Evaluation of the Morehead-Gano Log House," 2.

21 Terry G. Jordan, "The Imprint of the Upper and Lower South on Mid-Nineteenth-Century Texas," *The Annals of the Association of American Geographers* 57, no. 4 (1967), 690. His evolving study of this question was also published in Terry G. Jordan, "Population Origin Groups in Rural Texas," *Annals of The Association of American Geographers*, 60, no. 2, (1970), Annals Map Supplement Number 13, pp. 404–5, which gives greater detail of international origins; Terry G. Jordan, "The Texan Appalachia," *Annals of the Association of American Geographers*, 60, no. 3, (1970), 409–27; Terry G. Jordan, *Immigration to Texas*, Boston: American Press, 1980).

22 Jordan, "Evaluation of the Morehead-Gano Log House," 1.

23 Terry G. Jordan, "Log Construction in the East Cross Timbers of Texas," *Proceedings of the Pioneer America Society*, 2, 1973, 107–24.

24 He used this term (and opened with a joke about his wife calling his obsession with log building a "complex") in a presentation at Winedale in 1973. See Terry G. Jordan, "Some Comments on Log Construction in Texas," *The Architecture of the Texas Frontier: A Series of Papers Delivered at the 1972 Winedale Workshop* (Austin: The Texas State Historical Survey Committee, 1973), 59–76.

*Fig. 1. Antonio Pérez de Aguilar, **The Painter's Cabinet**, Mexico, 1769, oil on canvas, 49 ¼ x 38 ⅛ in. (125 x 98 cm), Museo Nacional de Arte, Mexico City.*

Haciendas, Homes, and Household Furnishings in Spanish Colonial New Mexico

Donna Pierce

The province of New Mexico was the northernmost area of the Spanish Viceroyalty of New Spain (now Mexico and Guatemala).[1] More than one thousand miles north of Mexico City, it was described by its governor Diego de Vargas in 1692 as "at the ends of the earth and remote beyond compare."[2] In spite of this, archeological and documentary evidence indicate that New Mexico participated in and contributed to the international trade market of the era. Local merchants profited from the commodities they shipped south over the Camino Real, as well as from the goods they transported back to New Mexico from Mexico, Europe, and Asia, including such items as high-quality Chinese porcelains and silks; European linens, brocades, and fine lace; painted and lacquered furniture; and majolica ceramics from central Mexico.[3] Trade goods produced by both Spanish settlers and local Pueblo Indians, as well as those acquired from Plains Indians, included painted and unpainted hides; buckskin clothing made from bison, elk, and deer; sheep and woolen goods; piñon nuts; salt; and wheat. All were traded south to Mexico.[4]

Although extensive trade existed in New Mexico in the seventeenth century, this paper will focus on the eighteenth century since it overlaps with the colonial history of Texas. Documentation of household goods and personal items in New Mexico is available from the eighteenth century in the form of several hundred extant wills and estate inventories, as well as a handful of dowries.[5] These documents represent a cross section of New Mexicans, from obviously wealthy individuals to much poorer citizens, including people of different ethnic backgrounds and professions. This essay will bracket the eighteenth century by discussing the dowry of a woman who married in 1721 and the estate inventory of a man who died in 1815. Since few objects survive from colonial New Mexico and even fewer can be linked to specific persons, descriptions in estate inventories and artifacts from archeological excavations have been matched in the illustrations here with extant examples or similar ones seen in paintings and portraits from Mexico, Peru, and Spain (fig. 1).

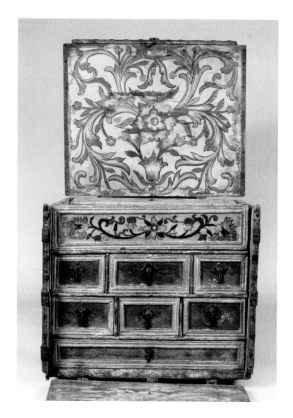

Fig. 2. ***Writing Chest (Escritorio)****, Michoacán, Mexico, eighteenth century, hardwood, gesso, paint, gold leaf, and iron hardware, 15 ½ x 18 ½ x 16 ¼ in. (39.3 x 47 x 41.3 cm) (closed), Museum of Spanish Colonial Art, Santa Fe, gift of Mrs. H. M. Greene, 1956.89.*

Dowry of Luisa Gómez del Castillo, 1721

On June 23, 1721, Luisa Gómez del Castillo married twenty-five-year-old military officer Juan Esteban García de Noriega in Santa Fe with former governor Antonio Valverde y Cosio as sponsor.[6] As the illegitimate daughter of an unmarried woman, Luisa was probably not as socially prominent as her groom. However, she brought a substantial dowry to the marriage. According to Spanish law, dower property was used by the husband during the marriage, but remained in his wife's family, thus securing her widowhood and her family after her death.[7] Luisa's dowry was formalized in 1723 in a written document which itemizes the objects but, unfortunately, does not assign individual values to them. Rather, the total value of the dowry is assessed as 2,500 pesos. After her mother[8] died in 1762, Luisa's dowry was included with the estate settlement and its current value was deducted from Luisa's inheritance, as specified by Spanish law.[9] In 1763 the total value of Luisa's dowry was revised to 2,260 pesos as part of the settlement of the estate, still almost half of the total estate value of 5,640 pesos (after payment of debts).

Fig. 3. **Table**, *New Mexico, eighteenth century, pine, 26 ¾ x 37 x 24 ¼ in. (68 x 94 x 61.6 cm), Museum of Spanish Colonial Art, Santa Fe, bequest of Alan and Ann Vedder, 1990.368.*

Hacienda

Luisa's dowry included a ranch in Santa Cruz de la Cañada, north of Santa Fe, described at the time of the marriage as having an adobe house of two rooms, an orchard, and two irrigable fields for planting. The list of livestock begins with six oxen, their cart and harness, followed by twenty-five cows with ten calves and two bulls; twelve brood mares with four colts or fillies; three mules; a riding horse with saddle, halter, and bridle; one hundred female sheep and two full-grown rams; twenty nanny goats and one kid billy goat; twenty large rams; two sows and one hog. By 1731 Juan Esteban is listed as a resident of Santa Cruz, and by 1733 he was the *alcalde* (mayor) for the Santa Cruz area.[10] To accommodate their family of five children, they probably expanded the two-room house.

Household Furnishings
Furniture and Bedding
At the time of the marriage, furnishings in the ranch house included a large trunk or chest, known as a *petaca*, a type covered with rawhide leather or woven buckskin. Luisa also had two regular chests and two writing chests, all four from Michoacán in central Mexico. Writing chests, or *escritorios*, had small drawers for holding writing

Fig. 4. **Coconut Chocolate Cup**, *Mexico, eighteenth century, coconut husk and silver, Museum of Spanish Colonial Art, Santa Fe, gift of Mary Cabot Wheelwright, 1956.53.*

supplies and other important items and were extremely popular all over Spain and Latin America (fig. 2). Both of Luisa's writing chests are described as "from Michoacán, painted in oil colors with their lockplates and keys." The Michoacán area of central Mexico had been known since before the arrival of the Spanish for the production of lacquered furniture and utensils, particularly trays and small gourd cups, or *jícaras* (from the Aztec word *xicalli*), used for drinking chocolate.[11] During the pre-Hispanic era, lacquer was made from an insect known as *aje* that thrived in the area. During the colonial period, the craft was continued with the encouragement of missionary friars and with influence from imported lacquerware from Asia. Painted and lacquered furniture from Michoacán was exported all over New Spain, including to New Mexico, where it frequently is mentioned in documents.[12]

Other furniture in the ranch house included two wooden benches, two chairs, a large table, one wooden bed, and an unpainted chest, all probably made locally in New Mexico (fig. 3).[13] Along with these were two mattresses; a new wool bedspread imported from Toluca (in central Mexico); three woolen blankets; and two pairs of bedsheets and two pairs of pillows made of cloth from Rouen, France, a type of fine lightweight wool or linen, often covered with small floral patterns.[14]

Silver Utensils

Dishes mentioned in the dowry include a handful of silver pieces, such as six new silver spoons, two small chests of silver, and a scalloped silver bowl (see fig. 1, middle

Fig. 5. José de Alcíbar, From Spaniard and Black, Mulatto, Mexico, c. 1760, oil on canvas, 30 ⅝ x 38 ¾ in. (77.8 x, 98.4 cm), Denver Art Museum, gift of the Collection of Frederick and Jan Mayer, 2014.217.

left). Another piece mentioned is a coconut cup mounted in silver "from Amula," a region in western Mexico in what is now Jalisco, just east of Zihuatanejo (fig. 4). Carved from the hard husk of the fruit of the Mexican Pacific coconut (a subspecies of *Coco nucifera L.*) and mounted in silver, such cups were popular for drinking hot chocolate in Latin America and were exported to Spain (see fig. 1, bottom center).[15]

Chocolate Utensils

Chocolate was a New World product—unknown in Europe before the encounter with the Americas. It had been cultivated and consumed by ancient civilizations there for centuries before the arrival of Europeans.[16] The beans of the cacao tree were fermented, dried, roasted, ground on a heated stone (*metate*), and mixed with water and spices, including chile, to make a drink. In the sixteenth century, chocolate drinking spread rapidly among Spaniards and then from Spain across Europe in the seventeenth century. In a painting of a mixed-race family in their kitchen in colonial Mexico, the woman prepares chocolate on the stove (fig. 5).

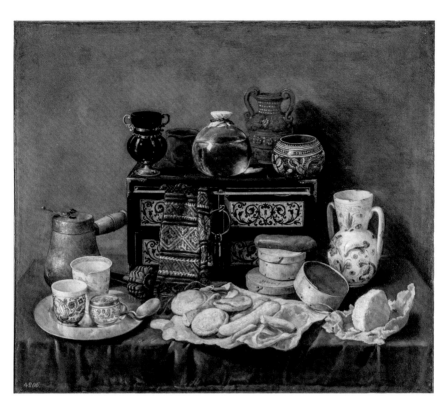

Top to bottom:
Fig. 6. Antonio de Pereda, **Still Life with Chocolate Chest**, Spain, 1652, oil on canvas, 31 ½ x 37 in. (80 x 94 cm), the State Hermitage Museum, St. Petersburg.

Fig. 7. **Basin (Lebrillo)**, Puebla, Mexico, late 1600s, majolica (earthenware, lead-tin glaze, cobalt in-glaze paint), 6 x 26 in. (15.2 x 66 cm), Denver Art Museum, funds from 2001 Collectors' Choice, 2001.314.

Spaniards had learned to drink chocolate from the Maya in the Yucatan and from the Aztecs in central Mexico.[17] Tall cylindrical earthenware vessels were used by the Maya to prepare chocolate. A Maya vase from the Late Classic period (c. 750) shows a standing woman pouring the liquid chocolate from one cylindrical vessel into another set on the floor—a technique described in other sources for creating foam, the most desirable part of the chocolate drink and much like the head on a glass of beer.[18] Possibly related to the tall vessels used by the Maya for chocolate preparation, a tall narrow vessel of copper or silver evolved in the colonial period to heat and beat the beverage, using a wooden whisk (known as a *molinillo*) to raise the foam by rubbing the handle rapidly between the hands (see fig. 1, bottom left and fig. 5, far right). Basically a colonial blender, the chocolate pot sometimes had a straight handle and a lid with a hole in the top to accommodate the handle of the whisk, as seen in a Spanish still life painting from 1652 (fig. 6, far left). Luisa owned a copper chocolate pot for beating and heating the popular drink.

In Latin America and Spain, the vessels of choice for drinking chocolate were the handle-less Chinese porcelain teacup (as we will see, Luisa had three); small majolica cups made in imitation of the former (Luisa had six); coconut cups set in silver (such as Luisa's, mentioned above); and the lacquered gourd cups made in Michoacán (Luisa had one). Examples of all can be seen in the Spanish still life (see fig. 6).

Among the Maya and Aztecs, chocolate had been a drink reserved for the upper classes or for special occasions; during colonial times it spread to all classes for daily use and was consumed in tremendous quantities all over Mexico, including in New Mexico where sherds of porcelain and majolica chocolate cups are found in archaeological excavations at colonial sites.[19] Mentions of chocolate drinking also appear in colonial documents. For example, in Santa Fe in the early 1660s, the Governor Bernardo López de Mendizábal and his Italian-born wife, Teresa de Aguilera de Roche, took chocolate every afternoon at three o'clock, and her personal chocolate chest (much like the one from Spain in fig. 6) included at least one Chinese porcelain cup, along with coconut cups and lacquered *jícaras*.[20] Governors and military leaders requisitioned chocolate for their troops, Franciscan friars imported it for use in the missions, and merchants carried it in their inventories.[21]

Majolica

Also in Luisa's dowry, six chocolate cups, a salt cellar, and eight plates are described as "from Puebla." These would have been made of *talavera* or majolica, a lead- and tin-glazed earthenware made in the town of Puebla, Mexico (fig. 7).[22] The thriving industry there inspired Fray (Friar) Juan Villa Sánchez to claim in 1745 that the pottery of

Fig. 8. **Water Jar**, Guadalajara area, Jalisco, Mexico, late eighteenth–early nineteenth century, earthenware with clay slip paint, 24 ³⁄₁₆ x 21 ¼ x 21 ¼ in. (61.5 x 54 x 54 cm), Museum of International Folk Art, IFAF, gift of the Fred Harvey Collection, FA.79.64-57.

Puebla "excels that of Spain and equals the beauty of the wares of China . . . [and] is in great demand throughout the kingdom."[23] Indeed, majolica from Puebla was brought to New Mexico in huge quantities, as described in shipping and estate inventories and as evidenced in archaeological excavations.

Porcelain

In addition to her majolica vessels, Luisa had three chocolate cups, three soup plates, and a large *tibor* (jar), all described as "from China." After the opening of trade with Asia through the Manila Galleon sea route in 1565, Chinese porcelain was imported into Mexico in large quantities. Its popularity was described by the English pirate Henry Hawks in 1582: "They have brought from China dishes and cups of earth so fine that every man that may have a piece, will give the weight of silver for it."[24] A Chinese porcelain plate can be seen on the lower shelf in the Mexican still-life painting (see fig. 1). Large quantities of porcelain made their way to remote areas, including New Mexico, where it appears in archaeological excavations and is mentioned frequently in documents.[25]

Mexican Earthenware

Two jars described in Luisa's dowry as "from Guadalajara" would undoubtedly have been the type of large water jars so prevalent throughout Mexico and exported to

Europe (fig. 8).[26] Hand-built and low-fired earthenware ceramics—in particular, large vessels for storing water—were produced both before and during the colonial period. The slightly porous quality of the vessels kept the water cool and was reputed to absorb bad odors in the water and to "purify" it. A cranky British Dominican friar, Thomas Gage, described them when he first arrived in Mexico in 1625 saying: "The inn-keepers . . . have special care so to lay in water in great earthen vessels, which they set upon a moist and waterish sand, that it is so cold that it maketh the teeth to chatter. This sweetness and coolness together of that water in so hot and scorching a country was a wonder to us."[27] These earthenware vessels were exported in large quantities to Spain and graced the tables of many upper-class Spanish homes. According to the French countess Marie-Catherine d'Aulnoy, when visiting Spain in 1680, the jars enriched the taste of water because the clay was porous and left a wonderful scent.[28] In addition to her two large water jars, Luisa also had several smaller serving vessels "from Guadalajara."

So we see that Luisa owned examples of all three types of ceramics: hand-built, unglazed, low-fired earthenware, sometimes called redware; wheel-thrown, hard-glazed earthenware known as majolica; and lightweight, thin-walled, glazed porcelain from Asia. Like Luisa, people in colonial Mexico often had a mixture of all three ceramic types in their homes. In addition, archaeological excavations in New Mexico reveal that all settler households also used locally made native Pueblo ceramics.[29]

Glassware and Other Dining Items

In the dowry, a glass pitcher or bottle and a small glass are noted as "for drinking water" (see fig. 1, bottom right). These may have been imported from Spain or Italy but were more likely from one of the glass factories established in Puebla, Mexico, by 1542, when a local official stated that "white, crystal, green, and blue" glassware from Puebla is used "by Spaniards and natives of these parts and as far away as Guatemala, and even further, arriving as far as Peru and other places."[30] Two hundred years later, a local priest claimed that Puebla glassware, "if not quite able to compete with Venice, [was] at least equal to that of France, double, strong, clean and clear, and of exquisite manufacture."[31] Other dining items in Luisa's dowry included several tablecloths, serving dishes, candlesticks, and various iron and copper kitchen utensils.[32]

Wall Hangings

The dowry lists various objects that can be considered wall decorations, including three painted elkskins with images of saints (similar to the one in fig. 9). Four other painted hides, in the bedroom, did not depict saints and may have functioned as

*Fig. 9. Unknown artist, **Crucifixion**, New Mexico, eighteenth century, water-based paints on buckskin hide, Museum of Spanish Colonial Art, Santa Fe, 1958.34.*

wall hangings more akin to tapestries or as bed curtains or door coverings.[33] Other wall decorations include a glass mirror and seven engravings, at least three depicting saints.[34] The final religious image mentioned is a crucifix with an image of Christ in bronze, with silver finials or caps on the ends of the cross.

Clothes

Something of a fashionista, Luisa brought into the marriage an extensive list of clothing, accessories, and jewelry. Providing an indication of importance, the very first item listed in the entire dowry is a hoop skirt (*pollera*) of brown silk brocade trimmed with silver braid, with a matching jacket.[35] Another hoop skirt of black silk satin with silver braid trim is also mentioned. Both were probably similar to the outfit worn by the young woman from Mexico City in a portrait from 1730–50 (fig. 10). Hoop skirts, supported by elaborate petticoats with bone, sapling, cane, or reed ribs, were exceptionally popular from the sixteenth through the eighteenth centuries in Europe and Latin America, although the shape and length varied by time and place.[36] They appear in other documents from New Mexico.[37] Often hoop skirts were slightly shorter than other skirts and were sometimes referred to as *tobajillas*, or "ankle-length skirts" (fig. 11). In the dowry, three skirts are described as *tapapiés*, meaning literally "cover the feet."[38] Of the three long skirts, a new one was made of red silk trimmed with silver braid. Two other silk skirts and four "everyday" skirts are also listed.[39]

Silver or gold braid trim (galloon or passementerie) was made from silk, cotton, or linen thread wrapped with tiny ribbons made of real gold or silver leaf.[40] The silver or gold-wrapped thread was then woven into fabrics or braided into tape or ribbon and sewn onto clothing as trim (see figs. 10–11). It can be seen in portraits of the era on clothing of both men and women (figs. 12–13). The fact that such trim was worn in New Mexico is documented in estate and traders' inventories. In addition, a few actual examples survive from New Mexico, including several fragments excavated from various locations[41] and a three-piece silk suit with gold braid trim decorating the jacket and the waistcoat (fig. 14).[42]

The dowry lists several shawls and scarves, including two black, one red, and one purple, all embellished with gold and/or silver braid trim and fringe. Yet another is listed as a red *rebozo*.[43] An example of this distinctive Mexican-style long, rectangular shawl can be seen around the shoulders of the woman in figure 5.[44] A new long cloak with embroidered edges is listed, as well as a short cape of silk tissue or lamé with metallic threads and silver braid trim described as "from China."[45] Clearly a fine piece, it demonstrates the availability of Asian materials in New Mexico.

Two blouses of Brittany linen are mentioned, one embroidered with black silk thread. Blouses made of linen from the Brittany coast of France were desired by men and women from the fifteenth through the eighteenth centuries in Europe and Latin America. In fact, Queen Elizabeth I of England favored them. Luisa's other Brittany linen blouse was decorated with sequins. Examples of sequined clothing survive in the National Museum of History in Mexico City.[46] Luisa also had a blouse of cloth from Rouen, France, the flowered lightweight wool or linen fabric mentioned above among her bed linens.

Accessories
Luisa brought into the marriage several fashionable hats, including a wide-brimmed hat trimmed with feathers and a small hat with feathers. The latter was probably one of the tiny "fascinator" types still worn today by royalty and upper-class women in Europe, especially in England. Small and tall, they were (and are) highly decorated and awkwardly placed forward on the head.

Luisa owned a pair of new silk stockings. Often of bright colors and embroidered at the ankles with colored or silver or gold thread, stockings made of silk or cotton were worn by both men and women in New Mexico. Some examples include a man's pair described as "blue silk stockings with fancy embroidery" and a woman's pair as "blue silk stockings embroidered with silver lace."[47] A gentleman from Albuquerque had "a pair of black silk stockings embroidered with satin stitch valued at 25 pesos", one of the more costly items in his estate.[48] A second lieutenant at the garrison of Santa Fe left an extensive list of clothing when he died in 1789, including "one pair of French cloth stockings" and "two pair of Chinese embroidered silk stockings,"[49] indicating that Luisa's stockings could have come from either place. Luisa also had a dozen pairs of flat shoes as well as one pair of shoes with high heels (see fig. 11). She had three pairs of silver shoe buckles that could be transferred from one pair of shoes to another.

The dowry also lists four kerchiefs made of cambric—a type of finely woven white cotton made in the town of Cambrai in northern France (see fig. 10). All four were trimmed with fine lace. From the sixteenth century on, production of both needle and bobbin lace had become a sophisticated art form in Italy, France, Flanders, and Spain and was exported to the Americas.[50] Ruffled lace sleeves and large kerchiefs were very popular in the eighteenth century, appearing in formal portraits.[51] Luisa also had a pair of gloves of scalloped lace.

Other accessories (seen in figs. 10–11) included two painted ivory fans "from China." Fans had become popular accessories in Europe and the Americas. Ivory objects imported from Asia to New Mexico in the colonial period are documented

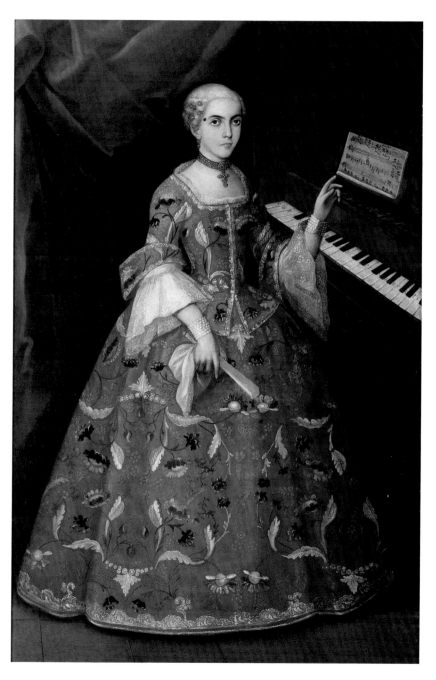

*Fig. 10. Unknown artist, **Woman with a Harpsichord**, Mexico, 1730–50, oil on canvas, 61 ⅝ x 40 ⅜ in. (156.5 x 102.5 cm), Denver Art Museum, gift of Frederick and Jan Mayer, 2014.209.*

From left to right:
*Fig. 11. Pedro José Díaz, **Portrait of Doña María Rosa de Rivera, Countess of Vega del Ren**, Lima, Peru, c. 1780, oil on canvas, 78 ¾ x 52 ⅜ in. (200 x 133 cm), collection of Carl and Marilynn Thoma, Chicago.*

*Fig. 12. Unknown artist, **Portrait of María del Carmen Cortés Santelizes y Cartavio**, Peru, c. 1760, oil on canvas, 31 x 25 in. (78.7 x 63.5 cm), Denver Art Museum, funds from Frederick and Jan Mayer, Carl and Marilynn Thoma, Jim and Marybeth Vogelsang, and Harley and Lorraine Higbie, 2000.250.2.*

*Fig. 13. Unknown artist, **Portrait of Simón de la Valle y Cuadra**, Peru, c. 1760, oil on canvas, 30.5 x 25 in. (77.5 x 63.5 cm), Denver Art Museum, funds from Frederick and Jan Mayer, Carl and Marilynn Thoma, Jim and Marybeth Vogelsang, and Harley and Lorraine Higbie, 2000.250.1.*

in archaeological excavations.[52] Ivory objects brought to New Mexico may have been imported from Asia ready-made, or made in Mexico from Asian bulk ivory, but Luisa's fans were probably made in Asia.

The English Dominican friar Thomas Gage lived in Mexico and Guatemala from 1625–37 and said: "Both men and women are excessive in their apparel wearing more silks than stuffs and cloth. Precious stones and pearls further much their vain ostentation."[53] Portraits of the day and quotes by foreign travelers indicate that people of all classes wore jewelry in colonial Latin America.[54] This seems to have been true to a certain extent in New Mexico as well.

Jewelry

Among the silver utensils in Luisa's dowry is an intriguing reference to a silver "*tembladera.*" This word literally means "trembler," but is sometimes used to describe a type of tankard. However, it is also the name for a type of hair ornament that was exceptionally popular in this era in Spain and Latin America made of silk flowers and jewels inserted into the hair or wig by springy wires so that they trembled or fluttered with the wearer's movements (see fig. 10).

Fig. 14. **Man's Jacket**, *Mexico or New Mexico, c. 1700, silk and gold-and-silk-thread braid, Museum of International Folk Art on long-term loan from the Collections of the Archdiocese of Santa Fe.*

Luisa had two pairs of matching coral bracelets as well as several bracelets of coral and green (glass) beads.[55] The fashion at the time included matching pairs of bracelets, such as the pearl cuff bracelets seen in figures 10–12. Next, Luisa's dowry lists a choker necklace of pearls mixed with corals with a reliquary locket in the middle (see figs. 11–12). Pearls and coral were abundant in Mexico and South America and were harvested at numerous locations along both the Atlantic and Pacific coasts.[56] Pearls were exported to Spain in such tremendous quantities that when Peruvian author Inca Garcilaso de la Vega (1539–1616) visited Seville in the late 1500s he commented that pearls from the Americas "were sold in a heap . . . as if they were some kind of seed."[57] Even young children had their own pearl and coral jewelry.

Thomas Gage, mentioned earlier, when speaking of women of African descent in Mexico said: "She will be in fashion with her necklace chain and bracelets of pearls, and her earrings of some considerable jewels."[58] This is born out in the painting of a free mulatto woman in Mexico in 1711 (fig. 15). Despite holding a lower social standing, she wears elaborate pearl and coral jewelry. Apparently this was true of Indian and mixed-race women as well. According to Father Juan Viera

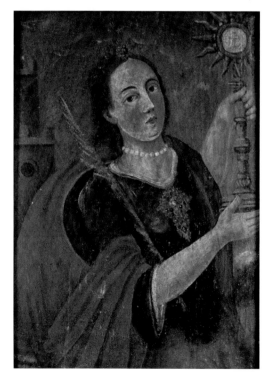

Clockwise:

Fig. 15. Manuel de Arellano, **Rendering of a Mulatta**, Mexico, 1711, oil on canvas, 40 × 29 ¼ in. (101.6 x 74.3 cm), Denver Art Museum; collection of Frederick and Jan Mayer, 16.2014.

Fig. 16. Juan Rodríguez Júarez, **Saint Rose of Lima with Christ Child and Donor** (detail), Mexico, c. 1700, oil on canvas, 66 x 42 in. (167.6 x 106.7 cm), Denver Art Museum, gift of Frederick and Jan Mayer, 2014.216.

Fig. 17. Bernardo Miera y Pacheco, **Saint Barbara**, New Mexico, c. 1782, oil on wood panel, Museum of Spanish Colonial Art, Santa Fe, gift of Gerald and Kathleen Peters, 2000.49.

Fig. 18. Juan de Sáenz, **Portrait of Francisco Musitu Zalvide**, Mexico, c. 1795, oil on canvas, 64 ¾ x 36 ¾ in. (164.5 x 93.3 cm), Denver Art Museum, in memory of Frederick Mayer with funds provided by Harley and Lorraine Higbie, Carl and Marilynn Thoma, and Alianza de las Artes Americanas, 2008.27.

reporting from Mexico in 1777: "Indian women . . . wear six or eight strings of pearls or coral around their necks, and reliquaries, and rings of gold or silver."[59] This was the case in New Mexico, as well; in 1753 Juana Galbana, a native of Zia Indian Pueblo, owned a pair of matching coral bracelets and two silver reliquaries (lockets with religious imagery).[60] Aside from her reliquary on the choker necklace, Luisa also had three additional silver reliquary lockets with one containing a wax image of the Lamb of God. These were probably interchangeable and able to be transferred from one necklace or pin to another.

In addition, Luisa owned multiple silver rings, religious medallions, four rosaries, and various neck chains, as well as several pairs of chandelier or multipendant earrings such as those seen in portraits of the era (fig. 16; also see figs. 11–12). Often these earrings were so large and heavy that the Countess d'Aulnoy wondered during her visit to Spain in 1680 how they did not tear the earlobes.[61] One of Luisa's sets was made of gold with both large and small pendant pearls; another pair was made of silver with a mixture of pearls and corals; and yet another pair was made of coral and rock crystal beads.

But the *pièce de resistance* in Luisa's jewelry collection was probably the large breast brooch or bodice ornament in the shape of a cross of gilded silver embedded with gemstones. Such large brooches were attached to the upper center of the bodice (usually sewn or tied on with thin ribbons) and were quite spectacular, some with faux stones of paste or glass, others with diamonds from Brazil (see fig. 11) and emeralds from Colombia (see fig. 16).[62] Although no portraits survive from colonial New Mexico, a painting of Saint Barbara by Santa Fe artist Bernardo Miera y Pacheco includes a cross-shaped gold breast brooch with gemstones, just like the one described in Luisa's dowry (fig. 17).

Estate Inventory of Captain Manuel Delgado, 1815

Almost a century after Luisa's marriage, Captain Manuel Delgado died intestate in Santa Fe in 1815. Delgado was born in 1739 in the town of Pachuca, north of Mexico City.[63] After enlisting in the military, he was stationed near El Paso (Texas) and was later transferred to the Presidio of Santa Fe. At the time of the 1790 census, Delgado was second in command at the Presidio and married to Josefa García de Noriega—from the same Santa Fe family Luisa had married into nearly 100 years earlier. The Delgados had at least five children by the time Josefa died in 1811. In 1814, at the age of seventy-five (and less than a year before his death) he married (the much younger) Ana María Baca and came to live at the family's extensive ranch called El Rancho de las Golondrinas (Ranch of the Swallows), now a living history

museum south of Santa Fe. Two of his grown children, one son and one daughter, had already married into the Baca family at the ranch.

Hacienda and Other Properties
In addition to being a military captain, Delgado was a trader on the Camino Real to Chihuahua and Mexico City. At the time of his sudden death in 1815, he owned a house and store in downtown Santa Fe and the ranch house at Golondrinas. He also owned four other ranches, along with other properties and mills.[64] Since he died intestate, a detailed and specific inventory was made of his estate.[65]

Household Furnishings
Clothing
Something of a clothes horse, Delgado had thirteen complete dress suits of velvet, silk, and cashmere distributed between his house in town and on his country estate at Golondrinas, including an elegant one of black silk velvet at Golondrinas, probably similar in cut to the one illustrated here (fig. 18). This list of thirteen fancy suits does not include his numerous suits of fine wool, some with silver or gold braid trim (fig. 19), including four at Golondrinas, nor his various suits of cotton fabric, including four at Golondrinas, nor his various three-piece suits of buckskin, some padded and quilted, with one of these at Golondrinas. To protect themselves from both weather and arrows, New Mexicans often wore vests or jackets made in Mexico or New Mexico of multiple layers of quilted buckskin (fig. 20). Although not mentioned earlier, Luisa also had a leather overcoat for outdoor wear.[66]

Accessories and Horse Gear
Like Luisa and other New Mexicans mentioned above, Delgado owned numerous pairs of silk and wool stockings, with seven pair at Golondrinas. At the ranch, he also had a long purple wool cloak, a short purple cape, eleven shirts of fine Brittany linen and two of unbleached muslin, assorted cravats and neck scarves, as well as two tricorn hats, a beaver felt hat trimmed with silver wire braid, silver shoe buckles, and a green umbrella. Even his horse was well dressed. His horse gear included a Spanish-style saddle, a bridle with silver trim, and an *anquera*, or leather rump cover, with metal pendants (fig. 21).

Fabrics
Unlike Luisa, Delgado also owned various items of large floral-printed cotton or chintz imported from eastern India and identified in the documents as *indianilla*.

Fig. 19. Unknown artist, **Portrait of Don Francisco Marcelo Pablo-Fernandez de Tejada y Arteaga, Marquis de Prado Alegre***, Mexico, c. 1760, oil on canvas, collection of Frank Carroll, Houston.*

From left to right:
*Fig. 20. **Buckskin overcoat**, Mexico, late eighteenth–early nineteenth century, buckskin leather and indigo-dyed wool trade cloth, 44 ⅞ x 19 ¾ in. (114 x 50 cm), Museum of International Folk Art, Santa Fe, IFAF, gift of the Harvey Collection, FA.79.64-97.*

*Fig. 21. Karl "Carlos" Nebel, **El Hacendado y su Mayordomo (The Hacienda Owner and his Foreman)**, Mexico and Paris, 1836, hand-colored lithograph based on drawings done in Mexico 1829–34, 11 x 17 ⅜ in. (28 x 44.1 cm), Museum of Spanish Colonial Art, Santa Fe, 2001.66.*

He also had fifty yards of indianilla bolt cloth for sale in his mercantile store. It was often used to make skirts for women and casual coats for men (see fig. 5), as well as for upholstery. At Golondrinas, Delgado had one three-piece suit, a lined bedspread, curtains, and other assorted pieces of indianilla. Fabrics were often attached to the lower portion of interior walls as wainscoting. At Golondrinas, two such wall linings of printed cotton are listed, one sixteen yards in length. The tradition survived in New Mexico into the twentieth century (fig. 22).

Books
An educated man, Delgado owned more than twenty-five books in Spanish and Latin, including ones on military law, criminal law, history, religion, natural science, etiquette, and assorted novels (see fig. 1, top right).[67] For the reading of these, Delgado owned several pair of silver-wire reading glasses. Apparently he was something of a musician as well since he owned a *bandolon*, a type of small lute (see fig. 1, top left).

Chocolate Utensils
In his Santa Fe store, Delgado had 168 pounds of chocolate for sale.[68] Chocolate and the attendant sugar were so valuable that majolica and porcelain jars were often fitted

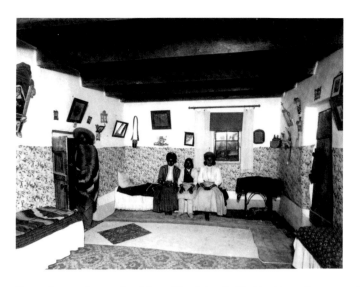

Fig. 22. *Interior, Governor Lente's house, Isleta Indian Pueblo, New Mexico, late nineteenth century, Palace of the Governors Photo Archives (MNHM/DCA), 012331.*

with locking iron lids to protect against temptation. Delgado had three of these large locking storage jars in Santa Fe, probably to store and protect the sugar and chocolate he had for sale there (fig. 23).

In addition to several copper chocolate pots for heating and beating chocolate, Delgado also owned a type of dish invented in the Americas for serving it. Referred to as *mancerinas*, these salad-sized plates were made with an attached ring in the center to hold a cup of chocolate and prevent it from spilling (fig. 24).[69] Sweet treats could be placed around the edge of the plate. Its origin and name have been credited to the Spanish Viceroy of Peru (1639–48) Pedro Alvarez de Toledo y Leyva, Marquis of Mancera. Apparently Mancera asked a silversmith in Lima to fashion such a saucer. Soon manufactured in majolica and porcelain, as well as metal, the mancerina (named after the viceroy) spread throughout the Americas and Europe specifically for drinking chocolate. Delgado owned a metal one at Golondrinas.

Like Luisa, Delgado had numerous pieces of Chinese porcelain including six chocolate cups and bowls at Golondrinas and nine at his Santa Fe home. Delgado had two majolica chocolate cups, along with plates and bowls, at Golondrinas and others in his Santa Fe home. He also had forty plates, thirteen cups, and four bowls of majolica "from Puebla" for sale in his Santa Fe store. In addition, Golondrinas was furnished with a large set of English white salt-glazed stoneware known as flint ware.

Glassware and Wine Vessels
At the ranch, Delgado had numerous vases and goblets of crystal, and others of regular glassware (see fig. 1, lower right).[70] The crystal pieces would have been imported from Europe, but the glassware could have come from the well-known glass factory in Puebla, Mexico, mentioned earlier. He also had two wine bottles, one of glass and the other mounted in silver,[71] and one large and one small wine cask (see fig. 1, middle right). Unfortunately, whether they are empty or full is not indicated.

Furniture
Like Luisa, Delgado and his wife also owned six chests and one writing chest, all seven from Michoacán.[72] Among other household items at Golondrinas were locally produced wooden furniture, sixty-eight yards of homespun wool (*jerga*) carpeting, a bearskin rug, a Navajo blanket, pillows of red Chinese silk, bed linens, embroidered and damask table linens, a large mirror, assorted clothes cabinets and chests, and, finally, he owned twenty-nine paintings and prints, all in frames made of worked silver (fig. 25).[73]

Although he died intestate, the household goods were divided among Delgado's five heirs with the ranch at Golondrinas split equally between his daughter, Manuela, who was married to a Baca, and his son, Marcos.

Conclusion
These two documents from colonial New Mexico provide a window onto the daily life of the era. We see that fabrics and lace were imported from France, Spain, and Flanders; silks and porcelains from China; painted cottons from India; and majolica and lacquered furniture from central Mexico. We also find distinctively hybrid objects that combine native American and Spanish American solutions to New World needs. For example, the tall copper chocolate pots (probably based on Maya prototypes), the Pre-Columbian gourd cups, and local coconut cups were all used for the consumption of American chocolate. In addition, buckskin clothing was made from American bison and elk to meet the local need for protection from weather and arrows. By matching the descriptions of material culture in the documents to archaeological fragments, surviving examples, and portraits of the era, we can begin to flesh out the lifestyle of a middle- to upper-class family on the remote frontier of the Spanish colonial empire in what is now the southwestern United States.

Counter-clockwise:
Fig. 23. **Chocolate Jar with Locking Iron Lid**, Puebla, Mexico, eighteenth century, majolica (earthenware, lead-tin glaze, cobalt in-glaze paint) and iron, collection of Michael Haskell, Santa Barbara, California.

Fig. 24. **Mancerina**, Mexico, late eighteenth century, silver, 3 x 9 ⅛ (7/5 x 23 cm), Museum of International Folk Art, Santa Fe, IFAF, gift of the Fred Harvey Collection, FA.79.64-4.

Fig. 25. Nicolás Enríquez, **Virgin of Guadalupe**, Mexico City, mid–late eighteenth century, oil on copper with worked silver frame, 33 ¼ x 25 in. (84.4 x 63.5 cm), Denver Art Museum, gift of Frederick and Jan Mayer, 2013.303.

Notes

1 Portions of this essay are adapted from Donna Pierce, "Unpacking a Colonial Bride: The 1721 Dowry of Luisa Gómez del Castillo of Santa Cruz de la Canada, New Mexico," in *Scholar of the City Different: Papers in Honor of Cordelia T. Snow*, Papers of the Archaeological Society of New Mexico, ed. by Emily J. Brown, Matthew J. Barbour, and Genevieve N. Head, vol. 45 (2019), 181–95; and Donna Pierce and Cordelia T. Snow, "Hybrid Households: A Cross Section of New Mexican Material Culture," in *Transforming Images: New Mexican Santos In-Between Worlds*, ed. Claire Farago and Donna Pierce (University Park: Pennsylvania State University Press, 2006), 101–16.

2 John L. Kessell and Rick Hendricks, eds., *Remote Beyond Compare: Letters of Don Diego de Vargas to His Family from New Spain and New Mexico, 1675–1706*, Vargas Series 1 (Albuquerque: University of New Mexico Press, 1989), 168.

3 In the seventeenth century, most governors of New Mexico made their fortunes cornering the business and were accused by their successors of abuse of power and forced to endure an inquiry in Mexico City at the end of their tenure. Private traders existed as well.

4 For more information on merchants and trade, see Max L. Moorhead, *New Mexico's Royal Road: Trade and Travel on the Chihuahua Trail* (Norman, OK: University of Oklahoma Press, 1958); Christine Mather, ed., *Colonial Frontiers: Art and Life in Spanish New Mexico, The Fred Harvey Collection* (Santa Fe: Ancient City Press, 1983); Christine Preston, Douglas Preston, and José Antonio Esquibel, *The Royal Road: El Camino Real from Mexico City to Santa Fe* (Albuquerque: University of New Mexico, 1998).

5 These unpublished estate inventories and wills are located in the New Mexico State Records Center and Archives in Santa Fe, Spanish Archives of New Mexico (SANM) I and II. For a similar discussion of household furnishings in San Antonio, Texas, in the eighteenth century, see Kelly Donahue-Wallace, "A Journey of a Thousand Miles Begins with a Lot of Luggage: Spanish Colonial Material Culture in the U.S. Southwest," in *American Material Culture and the Texas Experience, Papers of the David B. Warren Symposium*, vol. 1 (Houston: Bayou Bend Collection and Gardens, the Museum of Fine Arts, Houston, 2009), 66–87.

6 Fray Angélico Chávez, *The Origins of New Mexico Families in the Spanish Colonial Period in Two Parts: The Seventeenth Century (1598–1693), and the Eighteenth Century (1693–1821)*, 1954 (reprint, Santa Fe: Museum of New Mexico Press, 1992), 182.

7 Susan Midgen Socolow, *Women of Colonial Latin America* (Cambridge, UK: Cambridge University Press, 2000), 9–10, 82–84.

8 Luisa's mother Juana Lujan had grown up in New Mexico on a "prosperous homestead near San Ildefonso [Pueblo], including Apache and other Indian servants." When the Pueblo Indians rebelled in August of 1680, Juana fled south with her parents and other settlers to El Paso del Norte (now Ciudad Juárez), where she remained for thirteen years. During her time in El Paso or shortly thereafter, Juana had three illegitimate children, possibly by a member of the Gómez Robledo family (also from New Mexico). The circumstances of her children's births and their paternity remain unclear, but the family returned north to New Mexico during the resettlement of 1693. At this point Juana seems to have begun using the surname Gómez del Castillo. She acquired land near where she had lived prior to the revolt in the new jurisdiction of Santa Cruz de la Cañada founded by Governor Diego de Vargas in 1695. She sued Ventura Esquibel for breach of contract in 1705 claiming that he had promised to marry her and she settled for financial compensation. She raised her children in what was at the time of her death a twenty-four room house on her ranch of San Antonio, ten miles north of the village of

Santa Cruz. She continued to acquire lands and livestock, to farm, and to trade goods south to El Paso and Chihuahua. She arranged prosperous and prominent marriages for her two sons and Luisa, and provided Luisa's substantial dowry. In 1732 she married Francisco Martín, a member of the extensive Martín family of northern New Mexico. Chávez, *Origins of New Mexico Families*, 182, 187, 213. Also see J. Richard Salazar (trans.) and Linda Tigges (ed.), *Spanish Colonial Women and the Law: Complaints, Lawsuits, and Criminal Behavior, Documents from the Spanish Colonial Archives of New Mexico, 1697–1749* (Santa Fe: Sunstone Press, 2016), 36, 40, 104n1, 199n12, 317n8.

9 SANM, II:556; Richard Ahlborn, "The Will of a New Mexico Woman in 1762," *New Mexico Historical Review* 65:319–55.

10 Chávez, *Origins of New Mexico Families*, 181–82; and J. Richard Salazar (trans.) and Linda Tigges (ed.), *Spanish Colonial Lives: Documents from the Spanish Colonial Archives of New Mexico, 1705–1744* (Santa Fe: Sunstone Press, 2013), 403n17, 410; and Salazar and Tigges, *Spanish Colonial Women*, 262–72.

11 Teresa Castelló Yturbide and Marita Martínez del Rio de Redo, *El arte de maque en México* (Mexico City: Fomento Cultural Banamex, 1980). Also see Mitchell A. Codding, "The Decorative Arts in Latin America, 1492–1820," in *The Arts in Latin America, 1492–1820*, ed. Joseph J. Rishel and Suzanne Stratton-Pruitt (Philadelphia: Philadelphia Museum of Art, 2006), 98–113.

12 SANM I: 48; 240; 252; 351; 371; 530; 539; 590; 793; 1055; 1060; 1219.

13 For general discussions of furniture made in New Mexico, see E. Boyd, *Popular Arts of Spanish New Mexico* (Santa Fe: Museum of New Mexico Press, 1974); Alan C. Vedder, *Furniture of Spanish New Mexico* (Santa Fe: Sunstone Press, 1977); and Lonn Taylor and Dessa Bokides, *New Mexican Furniture, 1600–1940: The Origins, Survival, and Revival of Furniture Making in the Hispanic Southwest* (Santa Fe: Museum of New Mexico Press, 1987). Although the latter is the most comprehensive study of the subject to date, Boyd is the only author above to make specific connections to Spanish and Mexican prototypes. For brief discussions on the latter topic, see Donna Pierce, "New Mexican Furniture and its Spanish and Mexican Prototypes," in *The American Craftsman and the European Tradition, 1620–1820*, ed. Francis J. Puig and Michael Conforti (Minneapolis: Minneapolis Institute of Art, 1989), 179–201; Donna Pierce, "Furniture," in *Spanish New Mexico: The Spanish Colonial Arts Society Collection*, ed. Donna Pierce and Marta Weigle (Santa Fe: Museum of New Mexico Press, 1996), vol. 1, 61–79; and Robin Farwell Gavin, *Traditional Arts of Spanish New Mexico: The Hispanic Heritage Wing at the Museum of International Folk Art* (Santa Fe: Museum of New Mexico Press, 1994).

14 In the sixteenth century, the predominant cloth produced in Rouen was fine lightweight fabric woven from wool imported from Burgos, Spain, probably dyed blue with woad produced in France, particularly around Toulouse. See Constance Jones Mathers, "Family Partnerships and International Trade in Early Modern Europe: Merchants from Burgos in England and France, 1470–1570" in *The Business History Review* 62, no. 3 (Autumn 1988): 367–97; and Gayle K. Brunelle, "Immigration, Assimilation and Success: Three Families of Spanish Origin in Sixteenth-Century Rouen," *The Sixteenth Century Journal* 20, no. 2 (Summer 1989): 203–20. Linen and canvas were also produced in Rouen and exported to the Americas. See Peter Boyd-Bowman, "Spanish and European Textiles in Sixteenth-Century Mexico," *The Americas* 29, no. 3 (January 1973), 334–58. Also see Elena Phipps, "The Iberian Globe," and "Global Colors: Dyes and the Dye Trade," in *Interwoven Globe: The Worldwide Textile Trade, 1500–1800*, ed. Amelia Peck and Amy Elizabeth Bogansky (New York: Metropolitan Museum of Art, 2013), 120–35. By at least the beginning of the eighteenth century, unpublished documents indicate that a fine fabric, probably linen, decorated with floral motifs had become a major export item from Rouen to the Americas.

15 Gustavo Curiel, "Customs, Conventions, and Daily Rituals among the Elites of New Spain: The Evidence from Material Culture," in *The Grandeur of Viceregal Mexico: Treasures from the Museo Franz Mayer*, ed. Héctor Rivero Borrel M. (Houston: The Museum of Fine Arts, Houston, in association with Museo Franz Mayer, 2002), 23–42; 256–61. Also personal communication, 2018.

16 Ignacio H. de la Mota, *El libro de chocolate* (Madrid: Ediciones Pirámide, 1992); and Sophie D. Coe and Michael D. Coe, *The True History of Chocolate* (London: Thames and Hudson, 1996).

17 It is believed that the Maya drank their chocolate heated and the Aztecs consumed it as a cold drink. Spaniards followed the Maya practice of drinking chocolate hot.

18 This vase is in the collection of the Princeton Art Museum. See Donna Pierce, "Majolica in the Daily Life of Colonial Mexico," in *Cerámica y Cultura: The Story of Spanish and Mexican Mayólica*, ed. Robin Farwell Gavin, Donna Pierce, and Alfonso Pleguezuelo (Albuquerque: University of New Mexico Press, 2003), 244–69, 246.

19 Personal communication Cordelia Thomas Snow, Archeological Records Management Section of the Historic Preservation Division of the State of New Mexico, Laboratory of Anthropology, August 2016. Also see her excellent article "Objects Supporting Ideas: A Study of Archeological Majolica and Polite Behavior in New Mexico, 1598–1846," in *Inscriptions: Papers in Honor of Richard and Nathalie Woodbury*, Papers of the Archaeological Society of New Mexico, ed. by Regge N. Wiseman, Thomas C. O'Laughlin, and Cordelia T. Snow (2005), vol. 31, 187–97.

20 Archivo General de la Nación, Mexico City [AGN], Inquisición 593, exp. 1, f. 60; and Concurso de Peñalosa, vol. 1, ff. 395–400. Also see Donna Pierce, "At the Ends of the Earth": Asian Trade Goods in Colonial New Mexico, 1598–1821," in *At the Crossroads: The Arts of Spanish America and Early Global Trade, 1492–1850*, Papers from the 2010 Mayer Center Symposium, ed. by Donna Pierce and Ronald Otsuka, (Denver: Denver Art Museum, 2012), 155–82, 165.

21 Governor (1691–1707) Diego de Vargas considered chocolate a staple rather than a luxury for his troops (following the Aztec tradition), repeatedly requesting it in his supply requisitions. While traveling or in the field on military campaigns, it was often carried in bars and was the only sustenance served for breakfast and lunch, as a colonial equivalent to freeze-dried foods or power bars of today. Vargas also served it as a ceremonial drink to important figures including local Indian chieftains as a way of formalizing a verbal agreement (Kessell and Hendricks, *Remote Beyond Compare*, 1989; and Pierce, "Majolica in the Daily Life," 2003). For the missions see France V. Scholes, "The Supply Services of the New Mexico Missions in the Seventeenth Century," in *New Mexico Historical Review* (1930) 5:93–115; 186–210, 386–404.

22 Gavin, Pierce, and Pleguezuelo, *Cerámica y Cultura*, 2003.

23 Edwin Atlee Barber, *The Majolica of Mexico*, Art Handbook of the Pennsylvania Museum and School of Industrial Art (Philadelphia: Philadelphia Museum and School of Industrial Art, 1908), 17.

24 Richard Hakluyt, *The Principal Navigations, Voyages, Traffiques and Discoveries of the English Nation* (London: J.M. Dent and Sons, 1907[1597]), vol. 6, 291.

25 Donna Pierce, "Popular and Prevalent: Asian Trade Goods in Northern New Spain, 1590–1850," in *Beyond Silk and Silver*, ed. Dana Leibsohn and Meha Priyadarshini, Special Issue of *Colonial Latin American Review* (2016) 25:1:77–97. http://dx.doi.org/10.1080/10609164.2016.1180786. In New Mexico, porcelain usually appears as soup plates and chocolate cups, making Luisa's large tibor a

notable exception and indicating that luxury pieces, while not common, were not entirely unknown on the frontier.

26 María Concepción García Sáiz, "Mexican Ceramics in Spain," in *Cerámica y Cultura*, ed. Gavin, Pierce, and Pleguezuelo, 186–202.

27 Thomas Gage, *Thomas Gage's Travels in the New World*, trans. and ed. J. Eric S. Thompson (Norman: University of Oklahoma Press, 1965 [1648]), 45–46.

28 Countess D'Aulnoy [Marie-Catherine Le Jumel de Barneville], *The Lady's Travels into Spain, or A Genuine Relation of the Religion, Laws, Commerce, Customs, and Manners of that Country* (London: Thomas Davies, 1774 [1680]) 2 vols. [facsimile ed. London: Gale Eighteenth Century Collections Online Print Editions, 2018], vol. 1, 323.

29 Tewa, Powhoge, and Ogapoge polychromes are the most frequently found types in archeological excavations, but these are rarely mentioned in documents, probably due to their local availability and lower value. Cordelia T. Snow, personal communication, 2018.

30 Manuel Romero de Terreros, *Artes industriales en la Nueva España* (Mexico City: Librería de Pedro Robredo, 1923), 175–76 (translation by author).

31 Romero de Terreros, *Artes industriales*, 176 (translation by author). Although little colonial glass has been recovered from archaeological excavations in New Mexico, clearly some was present since pieces are occasionally mentioned in inventories, such as Luisa's and Manuel Delgado's examples.

32 The latter include a griddle (*comal*), ladle, cooking pot, kettle, mortar, roasting spit, and scissors.

33 See Donna Pierce, "Hide Painting in New Mexico: New Archival Evidence," in *Transforming Images: New Mexican Santos In-Between Worlds*, ed. Claire Farago and Donna Pierce (University Park: Pennsylvania State University Press, 2006), 138–44; and Donna Pierce, "'In the Style of that Country': The History of Hide Painting in New Mexico," in *A Moment in Time: The Odyssey of New Mexico's Segesser Hide Paintings*, ed. Thomas E. Chavez (Albuquerque: Rio Grande Books, 2012), 105–29.

34 One is described as an image of an angel on paper in its frame, probably a religious engraving of an archangel, possibly Saint Michael or Saint Rafael. Another depicted Saint Lugarda or Lutgardis, a thirteenth-century Cistercian nun from Belgium who was particularly devoted to the Passion of Christ; and a third was of Saint John of God, the sixteenth-century Portuguese saint who repented his dissolute youth by founding a home (that became the Order of the Brothers Hospitalers) to care for the infirm, especially children, in Granada, Spain. Four other prints are mentioned (but the subjects are not noted), bringing Luisa's total number of prints to seven.

35 Brocade is an elaborate type of patterned fabric in which the design is woven into the fabric with supplementary wefts that are discontinuous. Brocade was often embroidered as well with contrasting colors in metallic or silk thread. See Elena Phipps, *Looking at Textiles: A Guide to Technical Terms* (Los Angeles: Getty Museum, 2011).

36 James Middleton, "Reading Dress in New Spanish Portraiture," in *New England / New Spain: Portraiture in the Colonial Americas, Papers from the 2014 Mayer Center Symposium on Spanish Colonial Art*, ed. Donna Pierce (Denver: Denver Art Museum, 2016), 101–46.

37 SANM I: 48; 489; 530; 1055; 1060.

38 The fact that these are listed as *tapapiés* implies that other skirts, especially the two hoop skirts, may have been shorter *tobajilla* skirts. Although the word *tobajilla* is not used in Luisa's dowry, it does appear in other documents in New Mexico (SANM I: 48; 530; 1055; 1231).

39 Middleton, *Reading Dress*. Three of these were of wool serge, whereas a fourth is described as of white material (probably linen or cotton, possibly from Rouen) embroidered with blue designs. Such skirts were worn as casual overskirts or at times were worn underneath dressier overskirts.

40 Phipps, *Looking at Textiles*, 52, 56. The gold or silver ribbon usually had been glued to a very fine backing or substrate made from paper, leather, animal gut, or membrane.

41 Cordelia Thomas Snow, "A Brief History of the Palace of the Governors and a Preliminary Report on the 1974 Excavation," *El Palacio* (1974) 80:3:1–22.

42 The suit survives in the Collection of the Archdiocese of Santa Fe and is on long-term loan to the Museum of International Folk Art. For photos of all three pieces see Pierce, "Popular and Prevalent."

43 It is described as of "*media tela*" (half cloth), which seems to mean made of a mix of silk (warp) and cotton (weft) thread or that it was a narrow shawl, two-thirds to one-half the normal width.

44 Virginia Armella de Aspe and Teresa Castelló Yturbide, *Rebozos y serapes de México* (Mexico City: GUTSA, 1989).

45 The latter may have been imported ready-made "from China" or it may have been made in Mexico or New Mexico with fabric brought from China.

46 Virginia Armella de Aspe, Teresa Castelló Yturbide, and Ignacio Borja Martínez, *La historia de México a través de la indumentaria* (Mexico City: Iversora Bursatil, 1988).

47 SANM I:1060 and I:590.

48 SANM I:341.

49 SANM I:598.

50 Phipps, *Looking at Textiles*, 46.

51 One of Luisa's kerchiefs is described as having large lace trim known as *Vida Mia*, or "My Life." The dowry also includes loose fabrics and clothing accessories by mentioning various types of ribbon or fabric trim including five *varas* (33 1/2 inches or 85 cm) of wide silk satin (no color identified); a vara and a half of red "*media tela*" ribbon trim; and three varas of yellow silk satin ribbon trim.

52 Such as those excavated at San Gabriel and the Palace of the Governors. For San Gabriel, see Florence Hawley Ellis, *San Gabriel del Yunque: Window on the Pre-Spanish Indian World* (Santa Fe: Sunstone Press, 1988) and *When Cultures Meet: Remembering San Gabriel de Yunque Oweenge* (Santa Fe: Sunstone Press, 1970). These recovered artifacts are on long-term loan from San Juan Pueblo to the Maxwell Museum of Anthropology, University of New Mexico, Albuquerque. For the Palace of the Governors, see Snow, *A Brief History*.

53 Gage, *Travels*, 68.

54 Donna Pierce and Julie Wilson Frick, *Glitterati: Portraits and Jewelry in Colonial Latin America* (Denver: Denver Art Museum, 2015).

55 All Europeans used glass beads as gifts or trade items with Native Americans, including Spaniards in the Southwest. Most beads distributed by Spaniards were probably made in Venice, Spain, or in the glass factory that was operating in Puebla, Mexico, by 1542. Glass beads were popular as bracelets, choker necklaces, or rosaries, often with pendant *relicarios* (reliquaries) with religious imagery, such as the ones Luisa owned.

56 Columbus encountered native women wearing pearls in Venezuela on his third voyage in 1498 and the island of Cubagua was established as a center for pearl harvesting as early as 1528.

57 Neil H. Landman, Paula M. Mikkelsen, Rüdiger Bieler, and Bennet Bronson, *Pearls: A Natural History* (New York: American Museum of Natural History, 2001), 18.

58 Gage, *Travels*, 68.

59 Elizabeth Wilder Weismann, *Americas: The Decorative Arts in Latin America in the Era of the Revolution* (Washington, DC: Smithsonian Institution, 1976), 60.

60 For Juana Galbana, see SANM I:193. Other reliquary necklaces are mentioned in SANM I:48; 104; 193; 240; 530; 968; 1055. Examples of jewelry have been excavated from some archaeological sites in New Mexico as well. One exceptional example is a gilded glass drop earring in the shape of a pear excavated from the Palace of the Governors. Snow, *A Brief History*.

61 D'Aulnoy, *The Lady's Travels*, 307.

62 Unfortunately, the dowry document does not identify the types of gemstones in Luisa's brooch, but the use of the word *piedras* or "stones" implies that they were actual gems and not faux.

63 Fray Angélico Chávez, *Origins of New Mexico Families*, 168–69.

64 Unpublished document, SANM I: 252, inventory of the estate of Manuel Delgado, Santa Fe, September 14, 1815. He owned ranches at Pojoaque, Cerrillos, Cuyamungue, and El Vado. Portions of this article are adapted from Donna Pierce, "Thirteen Suits of Velvet, Silk and Cashmere: Clothing and Material Culture in Colonial New Mexico," in *Following Old Trails, Blazing the New: Proceedings of the 2007 ALHFAM Conference, Association for Living History, Farm and Agricultural Museums*, vol. 30 (2008), 168–76.

65 As a trader on the Camino Real, many of the goods in Delgado's possession were part of the inventory for his mercantile store in Santa Fe. The estate inventory clearly begins with a list of the merchandise in his store, but it is difficult to distinguish exactly when the list crosses over into his home on the same property in Santa Fe; in other words, between the objects for his personal use and those for sale in the store. However, his belongings at the hacienda at Golondrinas are specifically listed as at that location and there is no indication that they may have been for sale. Personal belongings are not listed at his other ranch properties, implying that he spent most of his time living at Golondrinas during the last year of his life.

66 Buckskin vests, jackets, overcoats, and suits for men were imported from Mexico, where they were often dyed a distinctive cinnamon color and trimmed with silver braid. Others were made locally.

67 One of the books listed was a copy of Agustín de Vetancurt's *Teatro mexicano* (Mexican Theater),

a history of the missionary effort in New Spain (including New Mexico) with descriptions of the people, lands, customs, and native religions, written by an Augustinian friar in 1624. See Fray Agustín de Vetancurt, *Teatro mexicano: Descripción breve de los sucessos [sic] exemplars de la Nueva-España en el nuevo mundo occidental de Las Indias* (Madrid: Colección Chimalistac, 1960).

68 Sixteen of the 168 pounds were formed into twelve small pieces, possibly like the bars used for military campaigns.

69 Pierce, "Mayolica in the Daily Life," 254; also see María Antonia Casanovas, "Ceramics in Domestic Life in Spain," in *Cerámica y Cultura*, ed. Gavin, Pierce, and Pleguezuelo, 48–75.

70 Some pieces in each of these categories are noted as having been broken and glued, indicating their perceived value.

71 The latter may have been of Chinese porcelain since it was common to mount these in silver at the time.

72 These prized painted and lacquered chests from Michoacán were relatively common in New Mexico. Of the 150 chests listed in the estate inventories I have reviewed, forty-nine, or roughly one-third, are specifically identified as from Michoacán.

73 Assorted ranching, farming, and carpentry tools are also noted at Golondrinas.

Detail, fig. 29

Material Culture in Texas Prehistory:
Shaping Nature's Raw Materials

Harry J. Shafer

The material culture of prehistoric Texas Indians is diverse and reflects the skill, ingenuity, and traditional knowledge required for survival in their respective environments. The preservation of ancient material culture is predicated by a number of factors: environmental conditions, kinds of raw material used, antiquity, and culture. Preservation depends on the depositional environment and varies from artifact assemblages composed entirely of stone for much of the state's prehistory to areas where conditions allow remarkable preservation. More humid areas have the poorest preservation, while perishable materials are more likely to be preserved in the arid regions of West Texas.

Environment and Natural Resources

The environment of Texas varies from humid, near-rainforest conditions in Southeast and East Texas to arid desert conditions in West Texas.[1] Vegetation across the state varies accordingly from the Piney Woods of East Texas to prairies in Central Texas, oak-juniper parkland across the Edwards Plateau and Balcones Canyonlands, thorny brush of South Texas, and the Chihuahuan desert of the Trans-Pecos region.[2] Each of the physiographic zones provided resources that helped to sustain the native peoples who inhabited them. People created their own material culture from the natural resources in their immediate environment, hence the variation in material and style across the state.

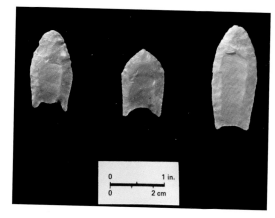

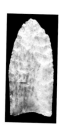

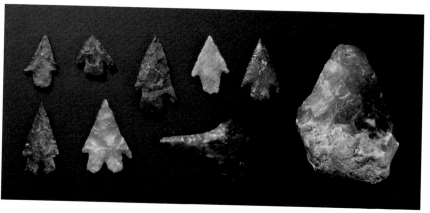

Top to bottom, left to right:

Fig. 1. **Clovis Spear Point**, *c. 11,500–10,800 BC, Alibates dolomite, Texas Archeological Research Laboratory, University of Texas at Austin.*

Fig. 2. **Folsom Spear Points**, *c. 10,800–10,300 BC, Edwards chert, Texas Archeological Research Laboratory, University of Texas at Austin.*

Fig. 3. Archaic Period artifacts: **Shumla Spear Points, Montell Spear Points, Corner-Tang Drill, and Fist Knife**, *c. 1500–1000 BC, Edwards chert, the Witte Museum, San Antonio.*

Fig. 4. **Perdiz Arrow Points**, *c. AD 1300–1650, Edwards chert, the Witte Museum, San Antonio.*

The most critical resource to create tools for hunting and utilitarian tasks around the camp was stone. The types of stone used were determined in part by what was available in the local geology,[3] or could be acquired through trade with neighboring groups who had access to good tool stone, such as siliceous rocks called flint or chert. This glass-like material, when struck with a stone hammer, created sharp-edge flakes that could be used for multiple tasks of cutting, scraping, drilling, piercing, or sawing. Nodules of chert were sculpted into projectile points, large knives that were carried from place to place, adze blades for woodworking and felling trees, or simply sharp-edge flakes for use as knives, gravers, or other tools.

The most prized stones for tools were chert from the Cretaceous-era Edwards and Devil's formations in the Edwards Plateau of central and southwest Texas[4] and the colorful Alibates "flint" or dolomite from the Canadian River in the Texas Panhandle.[5] These siliceous materials were heavily utilized by local groups and traded widely across much of the state and beyond. To the native peoples, good stone for tools was the essence of metal in our culture today.

Another important factor in the preservation and accumulation of material culture is the way of life of the people. Throughout much of cultural history, from the time of initial arrival, native peoples across Texas were mobile hunters and gatherers who moved from place to place within their territory to hunt and forage.[6] They sustained themselves using natural resources across their territorial ranges, housed themselves with makeshift huts covered in brush, skins, or woven mats, or, as in Central and West Texas, camped under natural overhangs, such as rockshelters and caves. Clothing was made of skins or soft fibers of local plants. Tools, utensils, and weapons were made of the materials at hand. Because they followed a mobile lifeway, material possessions were few and durable. There was no pottery, as it was not durable or practical. Containers were either woven or made mostly of skin. Nothing made of perishable materials by people in the eastern half of the state survived the ravages of time. Their story is told in stone, cooking hearths, and charred remains of plants.

Archaeologists have convincingly traced back the time when native peoples first settled in Texas to the Paleo-Indian period (about 12,000–10,000 years ago) with some controversial claims of somewhat earlier.[7] The earliest cultural assemblage recognized across the state, dating about 11,500 years ago, is called Clovis—the only people who hunted mammoths.[8] The Clovis interval was followed by descending cultures in time, such as Folsom and other late Paleo-Indian cultures known for their exploitation of now-extinct bison along with deer and pronghorn.[9] The functional roles of stone tools left behind, such as the distinctive spear points, scrapers, and knives, were designed for procuring and processing large animals.

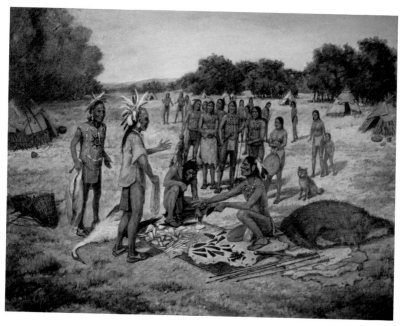

Fig. 5. Frank A. Weir, **Trading Partners**, *acrylic on gesso panel, 18 x 24 in. (45.7 x 61 cm), the Witte Museum, San Antonio.*

A gradual evolution of cultures, such as Clovis or Folsom who pursued large game, can be traced by the style of their spear points and the animals they hunted. The hunting weapon was a spear launched by a spear-thrower or atlatl.[10] The bow and arrow were not introduced to native Texas Indians for thousands of years.[11] The Clovis people were highly mobile and ranged across the entire state, as shown by the distribution of their distinctive projectile points (fig. 1) and fossilized bones of the animals they hunted. The geographic range of Folsom people, again traced by the distribution of their distinctive style of spear points (fig. 2) and bones of now-extinct bison, was mostly in the western half of the state.[12] These cultural adjustments were due to the shifting climate at the end of the Pleistocene era, as well as changes in the animal and growing human populations.

Material Culture Change through Time

The prehistoric populations in Texas increased from being sparsely populated during the Paleo-Indian period to experiencing gradual growth throughout the Holocene era (the last 10,000 years), to a projected million or more just prior to the Spanish appearance in the sixteenth century.[13] Material culture changed and accumulated

*Fig. 6. **Ear Spool and Beads**, c. AD 200–400, copper, Texas Archeological Research Laboratory, University of Texas at Austin.*

with the distribution of cultural groups across the landscape, the passage of time, and increasing populations.

Archaic Period

The distribution and density of material cultures at the end of the Pleistocene (about 10,000 years ago) show people settled into their respective environments forming territorial and social boundaries. Because most of the big game, such as mammoths and extinct bison, was now gone, hunting patterns changed and a much greater reliance was placed on gathering wild plants and hunting small game. This shift in subsistence emphasis is called the Archaic period, which lasted for at least 8,000 years across much of the state. Hunters and gatherers left stone tools, such as projectile points, knives, and scraping and boring tools (fig. 3). The tools left behind point to a broad range of activities. Cooking features, such as earth ovens that used hot stones for heat energy, reflect this lifeway shift and efforts to more intensively exploit local environments.

Craftsmanship in sculpting stone shows remarkable skill and efficiency during the Archaic period. As time passed, the style of projectile points and the appearance of different functional tools evolved, indicating changes in ecological conditions keyed by fluctuations in the climate. There is some indication that spear point styles were designed to hunt specific kinds of animals. Heavily barbed points, for example, occur in the areas and at times when bison were present; conversely, narrow points tend to occur when the primary large game was deer.[14]

The gradual warming and drying climate following the end of the Pleistocene was punctuated by cool, moist intervals.[15] These climate episodes are clearly reflected in the material culture across much of Texas for the next 10,000 years. A lifeway shift toward gathering and processing local plants followed the disappearance of

large game and the onset of dry conditions from about 10,000–6,000 years ago. A cool moist interval about 6,000–5,000 years ago attracted bison into Texas. Mobility was increased to follow the great bison herds, as indicated by the spread of material culture across much of the state. This event was short-lived, however, and there was a return to more localized hunting and gathering. This same pattern shift toward bison hunting occurred again across much of the South Plains and Central Texas about 2,500–2,000 years ago, and again about 700–300 years ago during other cool-climate episodes.[16]

The one major change in the hunting patterns of the hunters and gatherers and the later Formative cultures was the replacement of the spear thrower and spear with the bow and arrow. This replacement occurred across the state about AD 700 and is recognized by the appearance of delicate arrow points that are often referred to by laymen as "bird points" (fig. 4). Although modest in size, these arrows were lethal to any prey when shot by the small but powerful bows.

Formative Period

Native peoples of Central and South Texas never gave up hunting and gathering. Some populations in East and far West Texas increased over time and settled into specific environments and a greater emphasis was placed on exploiting local resources. Some forms of agriculture began to be incorporated into the subsistence schedules about 200 BC. This cultural shift is called the Formative period in American archaeology. With incipient agriculture came more permanent settlements and a longer duration of occupation in one place. This culture change took place all across the eastern United States and East Texas and is called the Woodland period.[17] In the American Southwest, including the far western part of Texas, the Formative period began with the onset of the Pithouse period about AD 200.[18]

East Texas Woodland and Caddo

Woodland cultures are marked by evidence of more sedentary settlements, more permanent dwellings, and mound building. This Woodland pattern extended into East Texas, and the artifacts from these mounds show a strong connection to the broader eastern United States pattern, especially the Woodland cultures of the Lower Mississippi Valley. Exotic artifacts acquired through trade (fig. 5), such as copper from the Great Lakes region, were made into gorgets, beads, and ear spools (fig. 6); other exotic artifacts include finely sculpted stone knives of foreign material (fig. 7), quartz crystals (fig. 8), conch shell ornaments (fig. 9), rattle stones called "boat stones," and pottery.[19] Pottery first appears in the archaeological record in East Texas about 200 BC, mostly as plain

Fig. 7. **Corner Tang Knives***, c. 1500–1000 BC, Edwards chert, Texas Archeological Research Laboratory, University of Texas at Austin.*

Counter-clockwise:
Fig. 8. **Figurine**, c. AD 200–400, quartz crystal, Texas Archeological Research Laboratory, University of Texas at Austin.

Fig. 9. **Shell Pendants**, c. 1500–1000 BC, Busycon conch, Texas Archeological Research Laboratory, University of Texas at Austin.

Fig. 10. **Marksville Stamped-Incised Jar**, c. AD 200–400, Texas Archeological Research Laboratory, University of Texas at Austin.

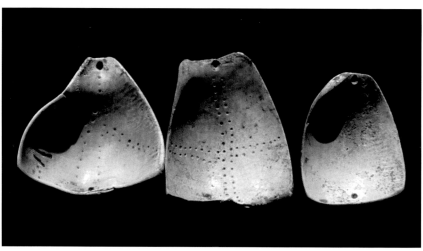

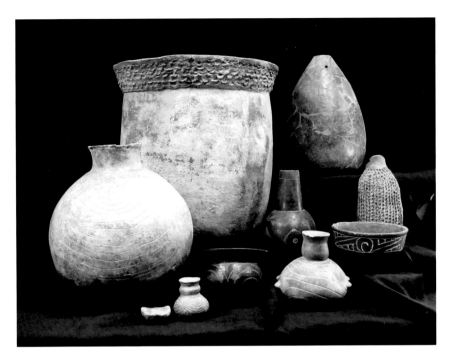

Fig. 11. **Caddo Pottery**, *c. AD 900–1600, Texas Archeological Research Laboratory, University of Texas at Austin.*

utility ware, but some jars are neck banded. More elaborate wet-paste incised and rocker-stamped jars, called Marksville Stamped (fig. 10), are decorated with the raptorial bird motif, marking them as vessels used in rituals and indirect connections to the Marksville culture in the Lower Mississippi Valley.[20]

The Woodland period in East Texas is followed by the early Caddo cultures.[21] There is a clear evolutionary growth from Woodland to Caddo about 1,000 years ago. Caddo villages range from family hamlets to elaborate villages with temple and burial mounds. Corn, beans, squash, and amaranth are among the plants grown by the Caddo. The Caddo lived in an environment that had poor stone resources for making tools—but they did have excellent clay. Pottery was not only highly functional in this setting, but vessel forms show a wide range of uses (fig. 11). Large utility jars show an evolution from the wet-paste rim patterns of the Woodland period. Bowls and bottles are elaborated with burnishing and fine-line engraving. Red or white pigments are rubbed into the engraved lines leaving pleasant decorative designs.[22] Ceramic smoking pipes indicate wide use of tobacco, and elaborate stone effigy pipes from the early Caddo tombs (about AD 1100–1200) underscore the ritual use of tobacco.[23]

Knives and axes were very important in any tool kit. Expedient knives were made from quartzite and chert pebbles in local gravels. Larger knives of chert were obtained from their kin or trading partners in Central Texas and beyond. Ground stone axe blades, called celts, and effigy pipes (fig. 12) were acquired from central and southwest Arkansas and elsewhere. Stone axes were used to fell pine and other trees to make the houses, wooden mortars, and other tools composed of wood. Conch shell for ornaments was obtained from the Gulf Coast. Conch was carved and engraved with deities and ritual symbols, which provides a hint as to the symbolic imagery of the time (fig. 13). One particular recurring image is that of a birdman deity (fig. 14). This figure has also been recognized in the layout of burials in elite tombs in East Texas, where this birdman was re-created in the costumes of the persons buried.

Information on textiles made and used by the Caddo is almost nonexistent due to the lack of preservation. Traces of decorated checker-weave mat from a tomb in Louisiana present a glimpse of what must have been an elaborate textile assemblage.

Throughout antiquity, the majority of travel across Texas was on foot—along well-worn foot trails or traces—with the exception of East Texas and coastal waterways. The Caddo and their coastal neighbors moved about and in dugout canoes, made of felled cypress trees and carved by charring and scraping the interior with stone adzes.[24] The horse did not become part of the Texas Indian material repertoire until acquired from the Spanish in the seventeenth century.

Desert Farmers of Trans-Pecos Texas

The farmers in far West Texas were broadly affiliated with the Pueblo cultures of the American Southwest, similar to the Caddo of East Texas and their affiliation with the cultures of the American Southeast. A regional pueblo culture developed out of an Archaic base in the deserts of far West Texas (around El Paso) about AD 200. Archaeologists define these cultural assemblages as the Jornada Mogollon, part of a widespread Mogollon cultural expression across southern and southwestern New Mexico.[25] The Jornada culture evolved through several phases defined by changes in architecture and ceramics. In the earliest phase, people began to use corn, squash, and beans as dietary supplements. The settlements were small hovels set in shallow pits and made of pole frameworks covered with woven mats. Pottery was plain brown ware and consisted of simple bowls and jars.

By about AD 1000, the architecture became more substantial and included puddled, adobe-walled structures in shallow pits. Local pottery also shows some elaboration, such as neckless jars being embellished with red designs on brown fabric by about AD 1100.

Clockwise:
Fig. 12. **Human Effigy Stone Pipe**, c. AD 900–1200, quartzite, Texas Archeological Research Laboratory, University of Texas at Austin.

Fig. 13 . **Shell Pendant, Busycon Conch**, Texas Archeological Research Laboratory, University of Texas at Austin.

Fig. 14. **Engraved Shell, Busycon Conch**, Sam Noble Oklahoma Museum of Natural History, University of Oklahoma, Norman, Oklahoma.

Fig. 15. Mimbres, **Bowl with Two Fish**, 1025–1150, earthenware with slip, the Museum of Fine Arts, Houston, museum purchase funded by Mrs. Robert E. Hansen in memory of Gene G. Gables, 89.207.

Left to right:
Fig. 16. **El Paso Polychrome Jar**, AD 1250–1350, mineral paint on brownware, United States Army, Fort Bliss, El Paso, Texas.

Fig. 17. **Ramos Polychrome Pottery**, El Paso Museum of Archaeology.

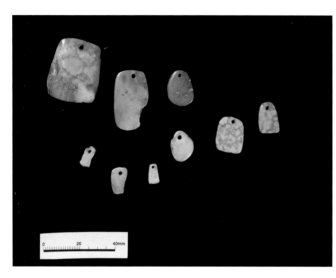

Fig. 18. **Stone Pendants**, AD 500–1300, turquoise, Texas Archeological Research Laboratory, University of Texas at Austin.

The people in far West Texas also interacted with people of the Mimbres Pueblo culture to the west and north in New Mexico and Casas Grandes region of northern Mexico. The Mimbres culture is best known for its exquisitely painted white-slipped pottery (fig. 15).[26] The people around El Paso obtained the Mimbres pottery through social interaction. Sherds of this fine pottery occur eastward to the Guadalupe Mountains in West Texas. Casas Grandes polychrome pottery also was traded into the El Paso area.

Contiguous room surface pueblos developed out of the single-room, shallow-pit structures around AD 1300–1450 in the Jornada Mogollon. Archaeologists identify this period as the El Paso phase. Locally made El Paso polychrome pottery was the dominant ware (fig. 16). The people took part in a widespread network of material exchange with the Pueblo and other groups across the Southwest. Through this network they obtained painted pottery from the Casas Grandes region of northern Mexico (fig. 17), turquoise (fig. 18), Pacific Coast shell for beads, and *Glycymeris* shell bracelets.

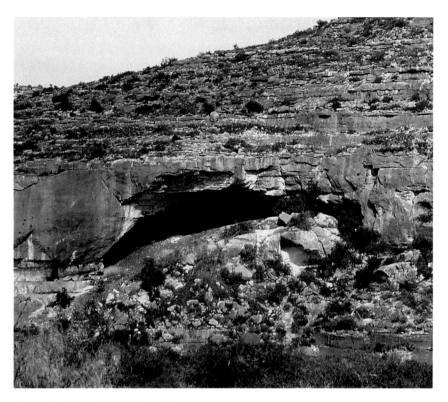

Fig. 19. Hinds Cave, Val Verde County, Texas.

Information on perishable material culture comes from excavations in dry caves in the region where favorable conditions existed for the preservation of organic materials. One such site is Ceremonial Cave near El Paso. Woven mats of sotol and agave, sandals of lechuguilla, spears, arrows, and wooden artifacts were all found preserved in the fill of the site. Such sites provide clues to the extent of their perishable culture.

Lower Pecos Canyonlands

One of the most remarkable regions for the preservation of ancient Texas Indian material culture is in the arid Chihuahuan Desert of the Trans-Pecos region. Most of this information comes from the Lower Pecos River Canyonlands in Southwest Texas. Here, the spring-fed Pecos and Devil's Rivers flow into the Rio Grande and created a desert oasis that attracted people to the area by 11,500 years ago, if not earlier. In these deep, rugged canyons are hundreds of rockshelters and overhangs

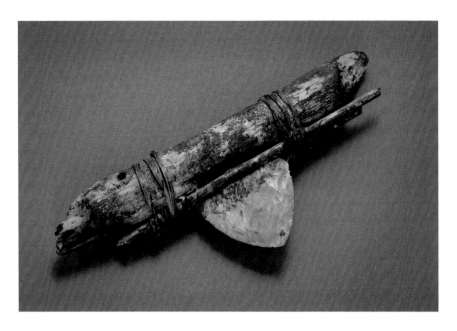

Top to bottom:
*Fig. 20. **Agave Knife**, Shumla Caves, Val Verde County, Texas, c. 5,000–2,000 BC, wood, yucca fiber, and Edwards chert, the Witte Museum, San Antonio.*

*Fig. 21. **Spear Fragments**, c. 5,000–2,000 BC, wood and stone point, the Witte Museum, San Antonio.*

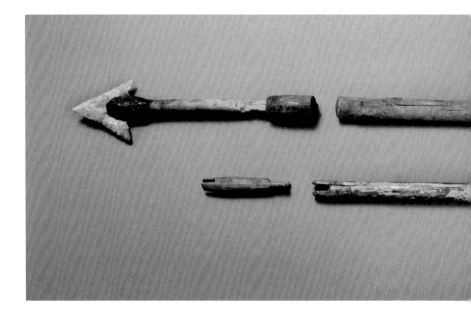

that provided protection from the elements; they also present and the most remarkably well-preserved and longest perishable record of hunters and gatherers in the United States.[27] This record includes impressive rock art murals on the walls of rockshelters and caves.

Many of the rockshelters, such as Hinds Cave near Comstock (fig. 19), were repeatedly occupied and left a historical record of material culture that dates back at least to 10,000 years. The deep layers of trash preserved in many of these rockshelters contain the byproducts of household activities. Spaces in shelters were allotted for sleeping, cooking, and even latrines. The inventory of preserved items is consistent through time, but style changes suggest that different people occupied the region at different times. The trash includes byproducts of food processing, earth ovens, grass floors, grass beds, stone tools (fig. 20), weapon parts (fig. 21), clothing (figs. 22–23), sandals (fig. 24), baskets (figs. 25–26), woven mats (fig. 27), bags, nets, wooden artifacts, bone tools, grinding implements, and painted pebbles (fig. 28). In addition, one of the most informative items is the preserved feces or human coprolites that unequivocally reveal the dietary meals. Together these artifacts provide the most comprehensive record of material culture for hunters and gatherers anywhere in the country, granting scholars to have a much clearer understanding of their ways of life.[28]

Regardless of the time period, the total range of material culture was created from resources in their desert environment. The peoples of this region sustained

Above:
Fig. 22. **Fur Robe**, *c. 4,000–2,000 BC, rabbit fur and yucca fiber cordage, the Witte Museum, San Antonio.*

Left:
Fig. 23. **Skirt**, *c. 500 BC–AD 500, yucca fiber cordage, Texas Archeological Research Laboratory, University of Texas at Austin.*

themselves with the local plants and animals that are not used for food today. Most of the textiles were made of local desert plants, lechuguilla (*Agave lechuguilla*), sotol (*Daslyiron spp.*), yucca (*Yucca torreyi*), and bear grass (*Nolina texana*). The fibrous leaves and other parts of these plants, including prickly pear (*Opuntia sp.*), were used for specific things. Lechuguilla, for example, was not only one of the most economically important plants, but the entire plant had a use; the bulbs were cooked in earth ovens along those of sotol for food, the fibrous leaves were used to make

Fig. 24. **Sandals**, *lechuguilla and yucca, the Witte Museum, San Antonio.*

sandals and cordage, and the dry flower stalks were used as spears, fire drills, split and used as fire hearth sticks, and used to make cradle or basket frames.

Sotol leaves were used to make checker-weave mats and baskets (see fig. 26), and the stalks were used for framing huts. Yucca leaves were used for finer-woven, diagonal checker-weave mats, baskets, and other containers (see fig. 27). Some baskets and mats were painted with red and yellow ochre. Yucca leaves, because of their long fibers, were split or stripped and—along with those from lechuguilla leaves—were used to make cordage, string, and rope, or as mere ties for bundles and sandals. The string was used for many things, including making nets, net bags, and net bodies to carry baskets.

Wood was also used to make tools and implements. Spears were composite tools made with lechuguilla stalks or saplings. The spear foreshaft was comprised of wood, and the stone points were attached to it with sinew (see fig. 21). Curved clubs called "rabbit sticks" were used in a variety of ways, mainly as clubs for slaying rabbits caught in a net, but also as a fending stick to work one's way through thorny brush. Wood also was used for carrying basket frames.

Clothing was sparse. Women wore short skirts made of string (see fig. 23) or strips of deer hide. Wraps or cloaks for warmth were made of strips of rabbit fur woven around a net framework. Men wore breechcloths of skin, and everyone wore sandals made of lechuguilla and yucca, or on rare occasion, hides. Undoubtedly

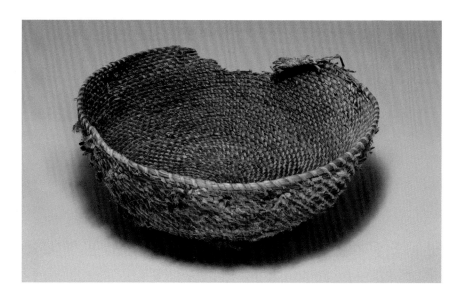

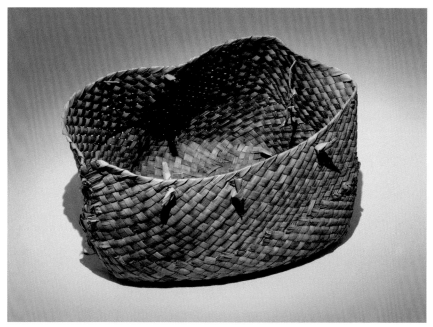

Top to bottom:
*Fig. 25. **Coiled Basket**, grass and yucca, the Witte Museum, San Antonio.*

*Fig. 26. **Plaited Basket**, sotol and yucca, the Witte Museum, San Antonio.*

Fig. 27. **Twilled Mats from Shumla Caves**, *sotol and yucca, Val Verde County, Texas, the Witte Museum, San Antonio.*

bison robes were used when the large game was either present in the region or in close proximity (as hides could be acquired through trade), but none have been recovered archaeologically.

Body decoration was probably done by tattooing. The only known ornaments were beads made of cut small-animal bones, carved mussel shell, or rarely stone beads or shell beads from the Pacific or Gulf Coast. Feathers were used to make headdresses, and headgear or costumes that also included deer antlers.

The stone tool industry is created entirely from chert found within the immediate environment. Spear points are among the more common stone artifacts. Changes in projectile point styles and technology are good indicators that different people moved in and out of the Canyonlands over time due to social or environmental pressures. Other stone tools were made and used to harvest the local desert succulents and for general household utilitarian tasks. Certain animal bones and antlers were also converted into tools such as bone awls, needles, and beads.

Portable art in the form of painted pebbles (see fig. 28) and rare clay figurines are among the items of expressive culture. Painted pebbles occur throughout the Archaic cultural sequence and show style changes through time. The functions of these interesting artifacts are not known, but probably correlate with the functions

for clay figurines in ancient Mexico or the American Southwest, such as in increase cults, curing rituals, or perhaps even as dolls.[29] Scholars suggest that the motifs depict female figures.[30]

The most extraordinary cultural expression in the Lower Pecos Canyonlands is the preserved rock art sites (fig. 29).[31] The antiquity of these impressive murals extends back to at least about 4,000 years ago, and some may be much older. The paintings are preserved in protected areas of more than 300 rockshelters on the Texas side, and an unknown number on the Mexican side of the border. There are at least four chronological styles represented, the most prominent of which is the Pecos River style, the oldest defined style in the region, which dates from about 4,200–3,100 years ago. Later styles include the Red Linear (undated), Red Monochrome (after AD 800), and Historic (after 1650).[32]

It is the Pecos River style that may help us identify some of the peoples of the Lower Pecos. There are more than two hundred documented Pecos River–style paintings on the Texas side of the border. Some Pecos River–style sites have a small cluster of figures, and others constitute long murals along cave walls that may extend for up to one hundred feet in length and reach a height of thirty feet. Perhaps the most impressive attribute of the Pecos River style is the density of sites in such a confined geographic range and temporal interval. The style occurs along the Rio Grande—from Del Rio to near Sanderson Canyon—northward from the Grande for about fifty miles, and southward about fifty miles into Mexico. The geographic distribution of the Pecos River style defines the territorial range of the ancient painters.[33]

The definitive traits of the Pecos River style are the anthropomorphic figures and other motifs painted in black, red, yellow, and white pigments (fig. 30).[34] The anthropomorphic figures are most prominent and typically show a figure holding an atlatl spear thrower and spear in the right hand. Faces are never depicted but are embellished in various ways. Deer antler headdresses, some tipped with black dots, are relatively frequent. Rabbit ears, cat ears, and halo-like caps are some of the distinguishing costuming on or above the heads of the anthropomorphic figures.[35] Some of the costumes cluster geographically, perhaps suggesting clan ownership of certain sacred sites or depicting visual narratives of characters in particular myths.

Dr. Carolyn Boyd, founder of the Shumla Archaeological Research and Education Center and professor of anthropology at Texas State University, has brought attention to the content of the Pecos River style by comparing the murals to ancient Mesoamerican books, or codices, of the of the Nahua speakers. If Boyd is

*Fig. 28. **Painted Pebble**, the Witte Museum, San Antonio.*

Above:
Fig. 29. The White Shaman mural site, Lower Pecos River Valley, near Comstock, Texas.

Left:
Fig. 30. Large, winged, antlered anthropomorphic painting over earlier anthropomorphic figures at Fate Bell Shelter, Seminole Canyon State Park, Comstock, Texas.

correct, and I tend to agree, each Pecos River pictographic site represents a page of a massive visual book that visually presents mythical stories—stories of the universe, the people's origin, and their ancestor migrations—as well as records celestial events such as solstices, equinoxes, and more. That is the power of these incredible murals. No other hunter-gatherer culture anywhere on the continent left behind such a spectacular legacy of their ancestral beliefs and understanding of the universe. Although no ancient culture in the United States developed a writing system, the Archaic hunters and gatherers of the Lower Pecos Canyons left a visual record of their beliefs in figures and symbols whose meanings have been interpreted by hundreds of generations of people.

Were the people who painted the Pecos River Style ancestors of the Nahua speakers of Central Mexico, those who claimed their origin was the deserts to the

north? There is no link from one to the other yet, but according to Boyd, there are murals in the Lower Pecos with characters, symbols, and motifs found in Nahua codices.[36]

Boyd has spent decades studying the White Shaman mural located on the Rock Art Foundation White Shaman Preserve of the Witte Museum. Her interpretation is that this particular mural explains the birth of the sun. One fascinating fact about the White Shaman figure is that it is headless—where the head would be is a broad red line. The figure, however, is also a celestial marker in that, on the day of the winter solstice, the sun's shadow caps the figure (or decapitates it, as Boyd's narration states).[37]

What happened to the painters of the Pecos River style? Two major events happened about 3,200–2,500 years ago that changed the cultural landscape in the Lower Pecos region. The first was a climate shift that peaked about 2,500 years ago that brought moist cool conditions across the Southern Plains.[38] The second, which was tied to the first, was the southern migration of great bison herds into the Lower Pecos region. The presence of bison in the Lower Pecos Canyonlands is well documented,[39] as are shifts in material culture that are tied more to Central Texas and Edwards Plateau cultures than to the Lower Pecos. In other words, the technological style recorded in the manufacturing of spear points and other tools suggest new people arrived into the Lower Pecos region. The arrival of new people who followed the bison resulted in a change in cultural traditions and expression, breaking the cultural patterns that led to the creation of the rock art. The creators of the Pecos River style may have been pushed southward, where they eventually developed into the great civilizations of Central Mexico, which trace their origins to the northern Mexican deserts.[40]

Conclusion

The material culture left by the prehistoric cultures across Texas—and throughout time—reveals much about their way of life. Their social characteristics as hunters and gatherers or formative agriculturalists, as well as technological changes, help to identify one archaeological group from another. Archaeologists can trace the evolution of social and technological change through time as populations increase across the state and adjust to changing ecological conditions over the past 12,000 years. Regardless of time and place, people used local natural resources to construct their basic needs of clothing and shelter, and their diets reflected the wild harvest and incipient cultivation of both native and intrusive plants such as corn, beans, and squash. With such cultivation came the need for pottery. Throughout time, the

people in Central and Southwest Texas remained mobile hunters and gatherers who centered their territories near the lush springs of the Edwards Plateau and spring-fed rivers of the Lower Pecos. It was one of the Lower Pecos groups that left the most complete material record of hunters and gatherers known in the country about 4,000 to 3,100 years ago, including hundreds of elaborately painted murals depicting their cosmos and creation. When one considers the greater context of the perishable and non-perishable material, as well as the spectacular polychrome murals and the stories they contain within such limited geographic space and time, the material legacy in the Lower Pecos Canyonlands is, without a doubt, one of the greatest archaeological treasures in the country.

Notes

1 E. H. Johnson, "Texas Regions," Handbook of Texas Online, https://tshaonline.org/handbook/online/articles/rzn01.

2 Stephan L. Hatch, "Texas Plant Life," in *Texas Almanac 2014–2015* (Denton: Texas State Historical Association, 2015), 114–17.

3 "Geology of Texas," in *Texas Almanac 2014–2015* (Denton: Texas State Historical Association, 2015), 87–88.

4 "Edwards Chert," https://texasbeyondhistory.net/trans-p/nature/images/edwards.html.

5 "Alibates Flint Quarries and Ruins," https://www.texasbeyondhistory.net/alibates/.

6 Harry J. Shafer, ed., *Painters in Prehistory: Archaeology and Art of the Lower Pecos Canyonlands* (San Antonio: Trinity University Press, 2013), 93–138.

7 Timothy K. Perttula, "Introduction to Texas Prehistoric Archaeology," in *The Prehistory of Texas*, ed. Timothy K. Perttula (College Station. Texas A&M University Press, 2004), 9.

8 Gary Haynes, *The Early Settlement of North America: The Clovis Era* (Cambridge, UK: Cambridge University Press, 2002), 59–66.

9 C. Britt Bousman, Barry W. Baker, and Anne C. Kerr, "Paleoindian Archeology in Texas," in *The Prehistory of Texas*, ed. Timothy K. Perttula (College Station: Texas A&M University Press, 2004), 15–100.

10 Harry J. Shafer, "Culture and Lifeways of Native Peoples in the Lower Pecos," in *Painters in Prehistory: Archaeology and Art of the Lower Pecos Canyonlands*, ed. Harry J. Shafer (San Antonio: Trinity University Press, 2013), 105–10.

11 Shafer, "Culture and Lifeways," 105–10.

12 Floyd B. Largent, Jr., Michael R. Waters, and David L. Carlson, "The Spatiotemporal Distribution and Characteristics of Folsom Projectile Points in Texas," *Plains Anthropologist* 36, no. 137 (November 1991): 323–41.

13 Although there are no accurate estimates for the Indian population in Texas prior to the arrival of the Spanish, based on the distribution, size, and density of archaeological sites that date to the last century prior to the first Spanish incursions, the population must have been at least a million or more.

14 Narrow spear points, such as the Angostura, Gower, Nolan, Travis, and Darl types, are found in Central Texas and Southwest Texas, where bison are absent and deer are the predominant large hunted game.

15 C. B. Bousman, "Paleoenvironmental Change in Central Texas: The Palynological Evidence," *Plains Anthropologist* 43 (May 1998): 40–59; Vaughn M. Bryant and Harry J. Shafer, "Late Quaternary Paleoenvironment for Texas: A Model for Archeologists," *Bulletin of the Texas Archeological Society* 48 (1977): 1–25.

16 William Foster, *Climate and Culture Change in North America, AD 900–1600*, Austin, University of Texas Press, 2012), 49–64.

17 Timothy K. Perttula, "The Prehistoric and Caddo Archaeology of the Northeastern Texas Pineywoods," in *The Prehistory of Texas*, ed. Timothy K. Perttula (College Station: Texas A&M University Press, 2004), 409–70.

18 Myles R. Miller and Nancy A. Kenmotsu, "Prehistory of the Jornada Mogollon and Eastern Trans-Pecos Regions of West Texas," in *The Prehistory of Texas*, ed. Timothy K. Perttula (College Station: Texas A&M University Press, 2004), 205–65.

19 Edward B. Jelks, "The Archeology of McGee Bend Reservoir, Texas" (PhD diss., University of Texas at Austin, 1965); Perttula, "Prehistoric and Caddo Archaeology," 376–78; Grant D. Hall, *Allen's Creek: A Study in the Prehistory of the Lower Brazos River Valley, Texas*, Research Report 61 (Austin: Texas Archeological Survey, University of Texas at Austin, 1981).

20 Harald P. Jensen, Jr., "Coral Snake Mound, X16SA48," *Bulletin of the Texas Archeological Society* 39 (1968): 40–44; "Caddo Ancestors, Woodland Culture," https://texasbeyondhistory.net/tejas/ancestors/woodland.html.

21 Perttula, "Prehistoric and Caddo Archaeology," 376–78.

22 "Created in Clay, The Caddo Pottery Tradition," https://texasbeyondhistory.net/tejas/clay/tradition.html.

23 Harry J. Shafer, "Lithic Technology at the George C. Davis Site, Cherokee County, Texas," *Friends of Northeast Texas Archaeology*, special publication no. 18 (2011).

24 Jeffery Girard and Charles R. McKinsey, "Current Research: Discovery and Recovery of a 14th-Century Dugout Canoe on the Red River, Caddo Parish, Louisiana," *Index of Texas Archaeology: Open Access Gray Literature from the Lone Star State*, article 5 (2019).

25 Miller and Kenmotsu, "Prehistory of the Jornada Mogollon and Eastern Trans-Pecos Regions," 205–65.

26 J. J. Brody, *Mimbres Painted Pottery* (Santa Fe: The School for Advanced Research Press, 2005); Harry J. Shafer, *Archaeology at the NAN Ranch Ruin, Grant County, New Mexico* (Albuquerque: University of New Mexico Press, 2003), 174–93.

27 Harry J. Shafer, *Ancient Texans: Rock Art and Lifeways Along the Lower Pecos* (Austin: Texas Monthly Press, 1986); and Shafer, *Painters in Prehistory*.

28 Shafer, *Ancient Texans*; and Shafer, *Painters in Prehistory*.

29 Harry J. Shafer, "Clay Figurines in the Lower Pecos," *American Antiquity* 40, no. 2 (1975).

30 Shirley B. Mock, "Painted Pebbles: Lower Pecos Women Take Charge," in *Painters in Prehistory, Archaeology and Art in the Lower Pecos Canyonlands*, ed. Harry J. Shafer (San Antonio: Trinity University Press, 2013), 223–40.

31 The majority of these spectacular rock art sites are on private property, but guided tours are provided at Seminole Canyon State Park and the Rock Art Foundation White Shaman Preserve of the Witte Museum.

32 Carolyn E. Boyd, "Drawing from the Past: Rock Art of the Lower Pecos," in *Painters in Prehistory: Archaeology and Art of the Lower Pecos Canyonlands*, ed. Harry J. Shafer (San Antonio: Trinity University Press, 2013), 182–96.

33 Harry J. Shafer, "Late Quaternary Paleoenvironment for Texas."

34 Boyd, "Drawing from the Past," 182–86.

35 James Burr Harrison Macrae, *Pecos River Style Rock Art: A Prehistoric Iconography* (College Station: Texas A&M University Press, 2018), 48.

36 Carolyn E. Boyd, *The White Shaman Mural* (Austin: University of Texas Press, 2016), 99–145.

37 Boyd, *The White Shaman Mural*, 141–42.

38 Bryant and Shafer, "Late Quaternary Paleoenvironment."

39 David S. Dibble and Dessamae Lorrain, *Bonfire Shelter: A Stratified Bison Kill Site, Val Verde County, Texas* (Austin: University of Texas, 1968); Shafer, *Painters in Prehistory*, 77–78.

40 Boyd, *The White Shaman Mural*, 99–145.

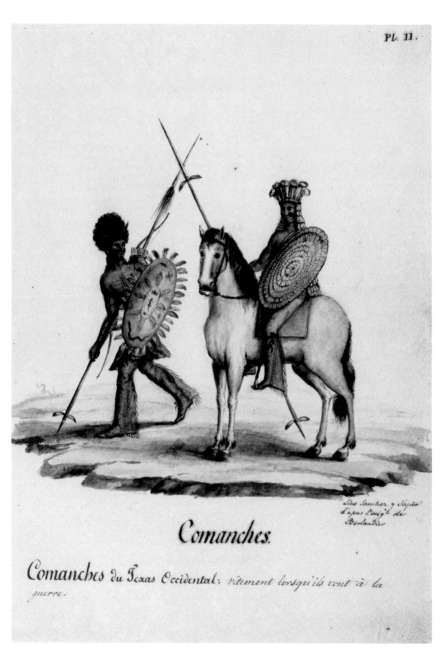

Comanches.

Comanches du Texas Occidental: vêtiment lorsqu'ils vont à la guerre.

Fig. 1. Lino Sánchez y Tapía, **Comanches du Texas Occidental***, c. 1828–34, watercolor, the Gilcrease Museum, Tulsa, Oklahoma.*

Contested Cultures:
Native Dress in Spanish and Mexican Texas

Mark A. Goldberg

In March 1800, a Spanish Texas colonist named Juan José Hernández was arrested for treason in San Antonio. He arrived in the city dressed as a Comanche Indian, which became the basis for the colonial state's case. Hernández had a colorful past. He was a ranch worker and, by the end of the 1700s, he had traveled throughout Texas unsuccessfully looking for work. He lived with various Native communities, and he had also been arrested multiple times before 1800. In 1794, for example, he was tried for sexually assaulting a young woman named María Martínez, who later retracted her accusation. In another case, not long before this fateful March day, he was jailed by the Spanish for having murdered a Tehuacano Indian while living with them. The Spanish and Tehuacanos were allies, which is likely why the Europeans imprisoned him upon his return to San Antonio. Hernández eventually escaped from jail and went to live with a Comanche band. After seven months with the nomadic Indians, he decided he wanted to return to Spanish society and went back to San Antonio. He broke an important rule, however, by failing to go straight to the Guardia Oficial, or the official guard, and present himself in the provincial capital. According to Hernández, who feared running into the Spanish military alone given his checkered past, he was on his way to an Indian friend's house, a man by the name of Javier, hoping Javier could vouch for him with the Guardia Oficial. Before arriving at Javier's, he was caught dressed as a Comanche, complete with a bow and arrow, and accused of being part of a group of Comanche men who had stolen six horses from a Spanish rancher the night before. Much of the case—the depositions and the defendant's testimony—hinged on Hernández's clothing (fig. 1).[1]

In a way, the focus on Hernández's clothes is not surprising. Dress serves as a symbol of one's identity, how one sees themselves. For example, a tie—a simple piece of fabric cut, tied, and knotted to create a particular shape—symbolizes seriousness, professionalism, and masculinity.[2] Wearing a tie, then, says something about the person wearing it. In colonial Texas, Spanish authorities were asking a similar question: what did Juan José Hernández's clothing say about the man? Did his Comanche garb mean he was a traitor and disloyal to the crown, or was it just circumstance since he had been living with Comanches and had no other clothes? They ultimately ruled the

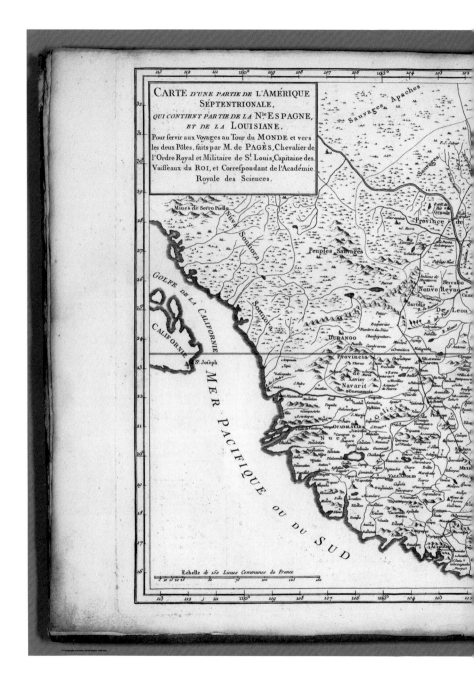

Fig. 2. Pierre Marie François Pages, **Carte d'une partie de l'Amerique Septentrionale (Map of New Spain)**, *1782, the David Rumsey Historical Map Collection.*

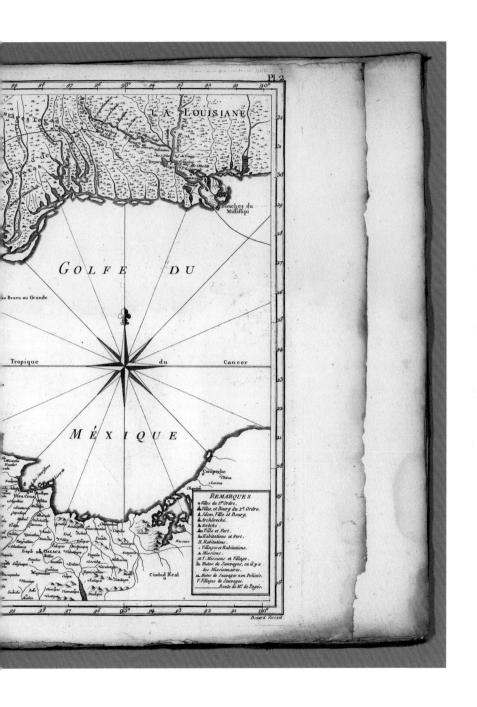

Pl. 2

LA LOUISIANE

Bouches du Mississipi

GOLFE DU

Rio Bravo ou Grande

Tropique du Cancer

MÉXIQUE

Campeche
China
Lorma
Chautin

Vera Cruz

OAXACA

Ciudad Real

REMARQUES
● Villes du 1.er Ordre.
▲ Villes, et Bourg du 2.e Ordre.
△ Idem, Ville et Bourg.
♦ Archevêché.
♦ Evêché.
♦ Ville et Fort.
□ Habitations et Fort.
П Habitations.
○ Villages et Habitations.
✚ Missions.
M.V. Missions et Village.
Ⓜ Hutes de Sauvages, où il y a
des Missionnaires.
⊡ Hutes de Sauvages nom Policée.
V. Villages de Sauvages.
········ Route de M.r de Pagée.

former, and he was found guilty and sentenced to four years of unpaid labor in the provinces of Sonora and Coahuila.[3] In Hernández's case, the Spanish decision reflected real anxieties about Comanche power, as the Spaniards had previously battled the Texas Indians for control of trade and for their own security, and had essentially lost.[4] Beyond this case, Spaniards consistently discussed dress as part of the colonial process and their relationship with their Texas Indian neighbors.

The Spanish were obsessed with "types" of people and, for Spanish Texans, dress reflected what kind of Spaniard one was. Rooted in the Iberian Peninsula, Spaniards developed a complicated *casta*, or caste system, a series of racial categories organized in a hierarchy with "pure blood" Spaniards at the top and "barbaric" Indians and blacks at the bottom. The preoccupation over Native clothing really began with the Spanish idea that Indians were "doing something wrong," an old idea in colonial Mexico. Spaniards had been describing Indians in this way since the beginning of conquest, filtering their views of Indians through a Catholic lens.[5]

Dress reflected Spanish social ideals embedded in the castas, as it reinforced everyone's "proper place."[6] Military men and Catholic missionaries donned specific uniforms as part of their positions. Inside the South Texas Gulf missions, the Spanish established rules on Indian dress as part of the conversion process (fig. 2). By 1793, when Nuestra Señora del Refugio Mission was founded, there were three Spanish missions in the southern Gulf Coast: Refugio, Nuestra Señora del Rosario, and Nuestra Señora del Espíritu Santo de Zúniga (figs. 3, 4). The priests saw the missions as places to "lead [the Indians] gently so that little by little they will forget the barbarous customs which they practice and the licentiousness in which they lived on the Coast . . . [and to] succeed in attracting to the Missions, those Indians who fled from it."[7] They worked hard to mold Karankawa-speaking populations, who, for the Spanish, were "given over to all kinds of vices."[8] Dress played a central role in this process too.

The Karankawas included multiple bands, such as the Cocos, Copanes, Cujanes, Coapites, and the Karankawas proper. While the Spanish built the missions as sites of conquest through conversion, the Indians saw the missions in a different way. They incorporated the Spanish structures into their own subsistence cycles. In spring and summer, the Karankawas formed small groups to search for game inland, away from the coast. In the fall and winter, they returned to the coast and concentrated on fishing, small-game hunting, and gathering.[9] During the latter part of the calendar year, when they lived more sedentary lives, some Indians chose to live in the missions. The question is, why? It is possible that those Karankawas who decided to inhabit the missions were drawn there by sincere religious reasons. It is also possible that they

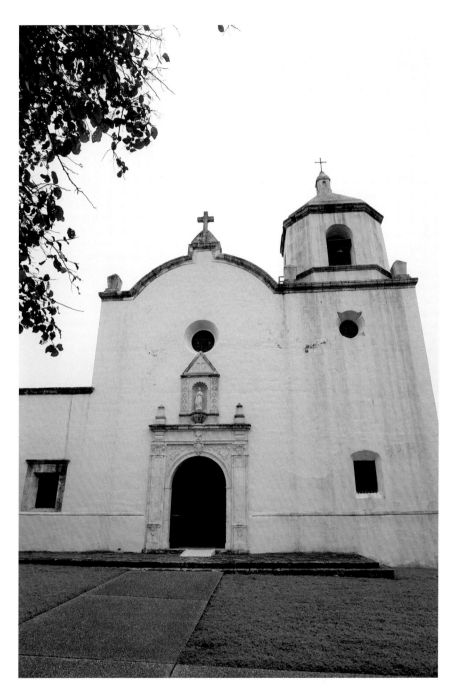

Fig. 3. Nuestra Señora del Espíritu Santo de Zúniga Mission, restored 1930s, Goliad State Park, Texas.

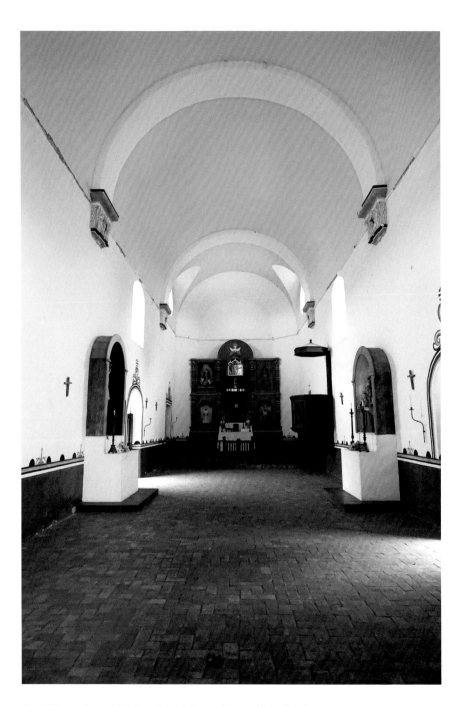

Fig. 4. Nuestra Señora del Espíritu Santo de Zúniga Mission, Main Chapel.

Carancahueses

Fig. 5. Lino Sánchez y Tapía,
**Carancahueses (Karankawa
Indians)**, c. 1828–34, watercolor, the
Gilcrease Museum, Tulsa, Oklahoma.

sought trade goods, food, and physical security from raiding Indians and aggressive
Spanish settlers.[10] Whatever pulled them there, the moment Native men and women
walked through the fortified walls surrounding the missions, they became objects
of reform. What's more, conversion was not simply about prayer. It also involved
instruction in colonial politics, law, agriculture, proper diet, and household living, as
well as Spanish marital traditions and gender, sexual, and family norms.

Dress also signified certain values. When living on the coast, Karankawa men
wore deerskin loincloths and wreaths made of plant fibers and ornamented with
feathers on their heads. Women wore buckskin skirts down to their knees and short,
sleeveless upper garments, also made of animal skins, leaving the midriff bare (fig. 5).[11]
We do not know the exact way Karankawa clothing reflected their social values, but
colonial Native American historians who study other groups show that Indian dress
often symbolized social and political status and military skill.[12] On the other side, we
have the missionaries (fig. 6). How did Texas missionaries, whose colonial perspectives
must have clashed with Karankawa principles, "read" the Indians dressed in this

Left:
Fig. 6. Priest's quarters, Mission Espíritu Santo.

Right:
Fig. 7. Mission Espíritu Santo School and Workshop.

way? Refugio missionary Fray José Francisco Mariano Garza described the Indians as exemplifying "nude shame."[13] Texas missionaries commented broadly on Indian clothing in the missions, which also revealed their overall perceptions of their Native neighbors. In a 1750 letter to the king, several priests wrote, "It was indecent for the Indians to enter the Church, attend the Holy Sacrifices of the Mass, and receive the Holy Sacraments with the inhumane slovenliness and nakedness with which they live in their uncultivated heathenism."[14] As a result, Fray Garza wrote that missionaries will make sure that "converted Indians dress according to the sovercign intentions of Our Catholic Monarch."[15]

Even though Spanish notions of Indian inferiority formed in the beginning of conquest, these ideas were still present in interactions with local Texas Indians. Spaniards tied these racial ideas to dress. In the late 1760s, for example, when Fray Gaspar José de Solís went from the mission college at Zacatecas to Mission Rosario, he commented on the Karankawas who lived there. He found the Indians "very dirty, foul-smelling and pestiferous, and they throw such a bad odor from their body that it makes one sick."[16] Converting Indians involved removing these so-called odors, which the Spanish also saw as a sign of unhealthiness.[17] The priests made Indians layer their clothing to cover up or get rid of those supposed smells.

At the same time, the missionaries used this layered clothing as a means to impose Catholic gender and sexual norms onto the Native peoples. Men were ordered to wear white linen shirts, pants, a hat, wool stockings, cotton socks, shoes, spurs, a wool pullover, white underwear, and a rosary. Women wore a blouse, a flannel skirt, linen underskirts, camisoles, petticoats, silk hose, shoes, earrings and necklaces, ribbons, and rosaries. Reflecting Spanish sexual concerns, mission Indian women were required to add "an extra piece of [linen]" to their skirts, "so that they are not too tight."[18] Form-fitting clothes clashed with Spanish Catholic expectations of dress. Missionaries tried to reform Indian behavior not only by dressing all Indians in "proper," modest clothing, but also by covering younger women's bodies in more layers than men's. The layered clothing protected young women's virtue.[19]

For the Spanish, the new clothing did not only signify the right values, it also translated into the right kind of work. Spaniards defined the Karankawa division of labor in the Indians' own communities as problematic and uncivilized. In Karankawa communities, men hunted and women grew and gathered food and prepared meals. Some of these tasks therefore changed in the missions. Men were to give up hunting and become farmers or ranch hands. A few mission Indian men trained to become blacksmiths and carpenters (fig. 7). This division of labor was reflected in dress, as the men wore clothes suitable for outside work in the colder fall and winter months—a hat, wool items such as a pullover, and spurs. Women were to

Fig. 8. Reproduction of a loom, Mission Espíritu Santo.

abandon agricultural labor and mainly perform domestic labor. For example, women spun thread and sewed (fig. 8). If married, they made their husband's clothes, and unmarried women made clothes for unmarried men. Missionaries segregated male and female labor, and they specifically prohibited women from helping men in the fields. This prohibition was also tied to ideas about sexual behavior, as the priests felt that a woman's presence "resulted in the men's not working fully because they paid too much attention to the women."[20]

These changes in Native dress and labor occurred when Karankawas chose to live in the missions. Ultimately though, the social ideals expressed through the missions' rules clashed with the realities of Indian conversion. The Spanish plan was to conquer Indians by converting and reforming them, which proved difficult to realize in Texas. Indians expressed their own autonomy when they could. For example, those who went to the missions in search of a steady food source often did not find one; missionaries could not provide sufficient food. Many Indians responded by leaving or stealing cattle from nearby missions and settlements.[21] This historical reality conflicts with how Texas history has been told—namely, that Spaniards arrived, did what they pleased, and conquered Texas. They certainly unleashed violent destruction and the spread of epidemic disease that ravaged many Native communities, but the Karankawas were able to maintain their way of life on the coast and control part of the territory, frustrating Spanish imperial designs.[22]

This Karankawa autonomy extended through the Spanish period and into the Mexican period, after Mexico achieved independence from Spain in 1821. By then, most of the Texas missions were secularized, meaning they were no longer serving as state-sanctioned sites of Indian conversion. The Mexican state sold mission lands to private landowners, and priests ran the individual churches. Some of the South Texas Gulf missions continued to operate as traditional missions for another ten years or so, though, while Mexican, Anglo, and Irish settlers established themselves in the area. It is unclear whether the Spanish mission guidelines for Indian clothing still functioned in the Mexican period. We do know that the Spanish preoccupation with Indian dress did not disappear with independence. In the late 1820s, the French naturalist Jean Louis Berlandier and Mexican artist Lino Sánchez y Tapía recorded Native customs, including dress, as they traveled with Manuel de Mier y Terán's expedition assessing the Texas border (see figs. 1 and 5). Because the South Texas Gulf Coast missions were not secularized until the 1830s, it is safe to assume the missionaries maintained the rules about dress since Karankawas continued to inhabit the missions for parts of the year. When the missions were ordered to be secularized, the Karankawas found themselves in the middle of a land battle between

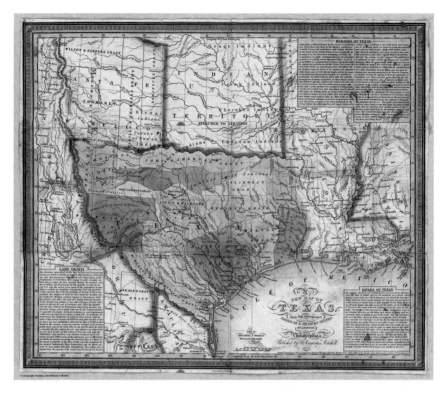

Fig. 9. Samuel Augustus Mitchell, **A New Map of Texas, with the Contiguous American and Mexican States**, 1836, the David Rumsey Historical Map Collection.

Martín de León, a Mexican landowner, and James Power and James Hewetson, two Irish immigrant landowners. Mexico was granting land to wealthy landholders as a way to colonize Texas and wrest control of territory from Native peoples (fig. 9). The land under dispute in the case of De León versus Power and Hewetson ran through the area of the missions. De León initially worked with the missionaries to prevent secularization because he knew this process would likely cause him to lose access to the mission lands adjoining his settlement—which is ultimately what happened. The missions were secularized; the settler population increased tremendously, pushing into Karankawa lands; and Karankawas, who survived skirmishes with settlers or the Mexican army, either fled entirely or moved into nearby towns, merging with the Mexican population.[23]

In conclusion, the story of Native dress is not simply about clothing, but the meanings people have attached to clothing and, by extension, to human bodies and notions of human types. During the Spanish colonial period in Texas, Spaniards

Fig. 10. Mission Espíritu Santo ruins.

projected racial fantasies onto themselves and their Indian neighbors, working to differentiate the two groups through dress in places where they had a semblance of control, such as the missions. In Spanish eyes, Karankawa clothing became a symbol of heathenism, unbridled sexuality, improper religious practice, and backwards gender roles. For the crown, it was up to the missionaries to carry out the colonial project by converting Native peoples, which meant more than religious instruction. South Texas Gulf mission Indians followed the rules by adopting Spanish-style clothing, which served as a lesson on how to live and work as good Catholic subjects. Of course, these guidelines and the ideas behind them meant very little outside of Spanish missions, presidios, and settlements (fig. 10), as Spaniards could not control life there, even though they tried. Karankawas responded to Spanish violent incursions with force and, for the most part, dictated the terms of the relationship with the Europeans. It is questionable if the Spanish even held control inside the missions, for Karankawas came and went as they pleased and stole mission livestock when they felt the priests did not deliver. There is even documentation suggesting mission Karankawas maintained some of their own religious rituals at the missions.[24]

The Spanish-Karankawa story teaches us how to think about Texas history. We are trained to see Texas Indians entirely as victims, for good reason, as they

eventually perished or forcibly fled their lands as a result of Spanish, Mexican, and, later, Anglo-American colonization. When viewed through that lens, however, we sometimes forget that Native peoples were not passive actors watching Spanish colonialism unfold in front of them. In the Spanish period, Karankawas were active barriers to conquest, as they pushed back and held on to their lands. The history of mission material culture reminds us that things were not always what they seemed, and colonial ideas came up against realities of Indian territorial control and agency. It is difficult to recover the history that tells us how eighteenth-century Karankawas understood the clothing that they wore, because for them, their dress was not a marker of incivility and inferiority, but rather a reflection of their social and cultural values. What we do know is that they did not simply abide by Spanish desires and, in turn, they deeply shaped the history of Texas.

Notes

Portions of this essay are adapted from Mark Allan Goldberg, *Conquering Sickness: Race, Health, and Colonization in the Texas Borderlands* (Lincoln: University of Nebraska Press, 2016).

1 Juan José Hernández treason case, March 1800, Ficha 764, Fondo Colonial, Archivo General del Estado de Coahuila, Ramos Arizpe, Coahuila (hereafter AGEC); Juan José Hernández sexual assault case, August 16–21, 1794, Medical History of Texas Collection, Dolph Briscoe Center for American History, University of Texas at Austin.

2 History shows that ties have become a marker of masculinity. For more on ties and masculinity, including female masculinity, see Alix Genter, "Appearances Can Be Deceiving: Butch-Femme Fashion and Queer Legibility in New York City, 1945–1969," *Feminist Studies* 42, no. 3 (2016): 604–31.

3 Juan José Hernández treason case, March 1800, Ficha 764, Fondo Colonial, AGEC.

4 For more on Comanche power during the colonial period, see Pekka Hämäläinen, *The Comanche Empire* (New Haven: Yale University Press, 2009).

5 For more on the history of castas, see María Elena Martínez, *Genealogical Fictions: Limpieza de Sangre, Religion, and Gender in Colonial Mexico* (Stanford: Stanford University Press, 2011).

6 Rebecca Earle, "Luxury, Clothing, and Race in Colonial Spanish America," in *Luxury in the Eighteenth Century: Debates, Desires, and Delectable Goods*, eds. Maxine Berg and Elizabeth Eger (New York: Palgrave Macmillan, 2003), 219–27.

7 Governor Manuel Muñoz to Fray José Francisco López, January 20, 1791, Mission Records, vol. 1, Spanish Archives, Béxar County Clerk, San Antonio, Texas.

8 Fray Gaspar José de Solís, "Diary of a Visit of Inspection of the Texas Missions Made by Fray Gaspar José de Solís in the Year 1767–68," trans. Margaret Kenny Kress, *Southwestern Historical Quarterly* 35, no. 1 (July 1931): 40.

9 Robert A. Ricklis, *The Karankawa Indians of Texas: An Ecological Study of Cultural Tradition and Change* (Austin: University of Texas Press, 1996).

10 For more on Spanish missions and Spanish-Indian relations in North America, see Juliana Barr, *Peace Came in the Form of a Woman: Indians and Spaniards in the Texas Borderlands* (Chapel Hill: University of North Carolina Press, 2007), Ramón A. Gutiérrez, *When Jesus Came, the Corn Mothers Went Away: Marriage, Sexuality, and Power in New Mexico* (Stanford: Stanford University Press, 1991); Steven Hackel, *Children of Coyote, Missionaries of Saint Francis: Indian-Spanish Relations in Colonial California, 1769–1850* (Chapel Hill: University of North Carolina Press, 2005); Elizabeth A. H. John, *Storms Brewed in Other Men's Worlds: The Confrontation of Indians, Spanish, and French in the Southwest, 1540–1795*, 2nd ed. (Norman: University of Oklahoma Press, 1996); James A. Sandos, *Converting California: Indians and Franciscans in the Missions* (New Haven: Yale University Press, 2004); and David J. Weber, *The Spanish Frontier in North America* (New Haven: Yale University Press, 1992).

11 Jean Louis Berlandier, *The Indians of Texas in 1830*, ed. John C. Ewers (Washington, DC: Smithsonian Institution Press, 1969), 161–62.

12 For colonial New England, see R. Todd Romero, *Making War and Minting Christians: Masculinity, Religion, and Colonialism in Early New England* (Amherst: University of Massachusetts Press, 2011).

13 Fray José Francisco Mariano Garza to Governor Muñoz, May 17, 1793, Béxar Archives, Dolph Briscoe Center for American History, University of Texas at Austin.

14 Fray Francisco Ballejo et al., "Memorial to the King, 1750," in *The Texas Missions of the College of Zacatecas in 1749–1750: Report of Fr. Ignacio Antonio Ciprián, 1749, and Memorial of the College to the King, 1750*, ed. and trans. Benedict Leutenegger (San Antonio: Old Spanish Missions Historical Research Library at San José Mission, 1979), 51.

15 Fray Garza to Muñoz, May 17, 1793, Béxar Archives.

16 Fray Gaspar José de Solís, "Diary of a Visit of Inspection of the Texas Missions Made by Fray Gaspar José de Solís in the Year 1767–68," trans. Margaret Kenny Kress, *Southwestern Historical Quarterly* 35, no. 1 (July 1931): 43.

17 For more on odor and health in the eighteenth century, see Kathleen M. Brown, *Foul Bodies: Cleanliness in Early America* (New Haven: Yale University Press, 2009).

18 Benedict Leutenegger, *Documents Relating to the Old Spanish Missions of Texas*, vol. 1, *Guidelines for a Texas Mission: Instructions for the Missionary of Mission Concepción in San Antonio*, 4th ed., eds. Howard Benoit and María Eva Flores, C.D.P (San Antonio: Old Spanish Missions Historical Research Library at Our Lady of the Lake University, 1994), 29.

19 For more on sex and virtue in northern New Spain, see Ramón A. Gutiérrez, *When Jesus Came, the Corn Mothers Went Away: Marriage, Sexuality, and Power in New Mexico* (Stanford: Stanford University Press, 1991), 207–26.

20 Benedict Leutenegger, *Documents Relating to the Old Spanish Missions of Texas*, vol. 1, *Guidelines for a Texas Mission: Instructions for the Missionary of Mission Concepción in San Antonio*, 4th ed., ed. Howard Benoit and María Eva Flores, C.D.P. (San Antonio: Old Spanish Missions Historical Research Library at Our Lady of the Lake University, 1994), 19–20.

21 José Antonio Cadena to Juan Cortés, June 8, 1794, Béxar Archives; Fray Manuel de Silva to Governor Muñoz, January 12, 1795, Béxar Archives; Fray Antonio Garavito to Juan Bautista Elguezabal, March 25, 1798, Béxar Archives; and Fray Garavito to José Miguel del Moral, October 27, 1798, Béxar Archives.

22 Mark Allan Goldberg, *Conquering Sickness: Race, Health, and Colonization in the Texas Borderlands* (Lincoln: University of Nebraska Press, 2016), 55–57.

23 Goldberg, *Conquering Sickness*, 57–66.

24 Fray Gaspar José de Solís, "Diary of a Visit of Inspection of the Texas Missions Made by Fray Gaspar José de Solís in the Year 1767–68," trans. Margaret Kenny Kress, *Southwestern Historical Quarterly* 35, no. 1 (July 1931): 40–41.

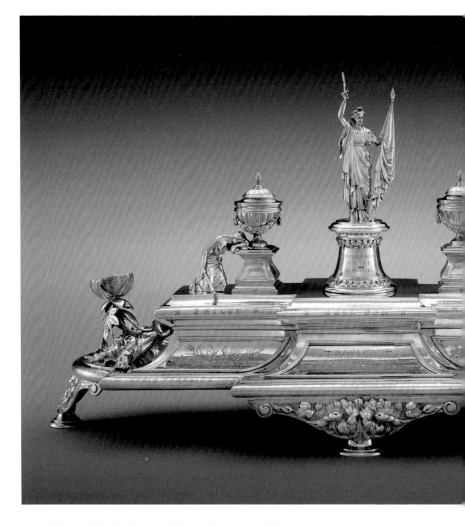

Fig. 1. Elkington & Co. (English, active 1829–1963), **Inkstand**, *1864–65, silver and glass, 13 ¾ x 26 x 9 ½ in. (34.9 x 66 x 24.1 cm), the Museum of Fine Arts, Houston, the Bayou Bend Collection, gift of the estate of Miss Ima Hogg, B.76.186.*

A Confederate Inkstand in England: Pro-Confederate Cotton Elites in Liverpool

Marjorie Denise Brown and Theresa R. Jach

An impressive silver inkstand in the Bayou Bend Collection serves as a window into the complex relationship between the slaveholding American South and British textile manufacturers in Liverpool (fig. 1). The ladies of the Liverpool Southern Club presented the inkstand to James Spence, a prominent Liverpool merchant who was sympathetic to the American Confederacy. The elaborate, ostentatious, and decidedly pro-Confederate presentation piece perfectly represents the ties of a certain group of British elites to the Confederacy.

Miss Ima Hogg purchased the inkstand in 1967 from Garrard & Co. in London.[1] As the crown jeweler, Garrard was responsible for the upkeep of the British royal jewels from 1843 to 2007.[2] John M. Graham II, director and curator of collections at Colonial Williamsburg in Virginia, facilitated Miss Hogg's acquisition of the Neoclassical inkstand. Garrard first offered the inkstand to Colonial Williamsburg, but it did not fit into their collection.[3] The year before, Christie's auction house had offered it for sale.[4] Elkington & Co., a premier silversmith in Birmingham, England, produced it in 1864 or 1865. Known for patenting the process of electroplating silver in 1840, Elkington produced many elaborate sterling silver works as well. Elkington's design books from the 1860s show many modified Neoclassical designs.[5] Like other

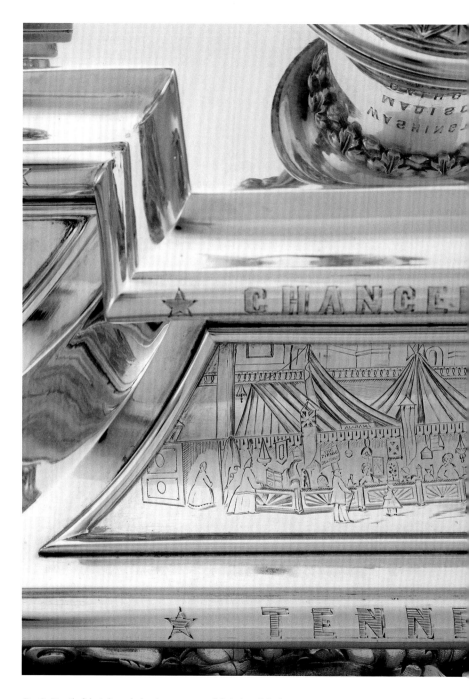

Fig. 2. Detail of the inkstand, showing an engraved depiction of the bazaar.

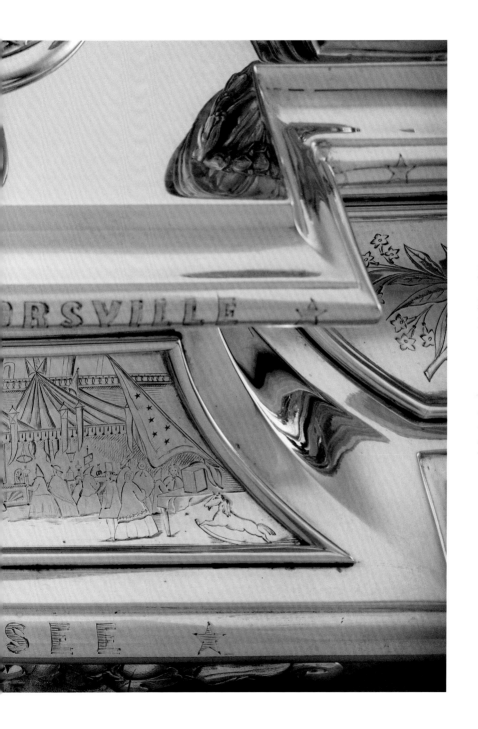

Left to right:

Fig. 3. The figure of Lady Liberty on the inkstand, under which are listed the names [Thomas] Jefferson, R. E. Lee, and [P.G.T.] Beauregard.

Fig. 4. Under the back of Lady Liberty are engraved the names of [George] Washington, [James] Madison, and [John C.] Calhoun.

large silversmiths, Elkington advertised their products at international exhibitions. These exhibitions were covered in newspapers, and the public enjoyed reading about the large presentation pieces and the people who owned them.[6]

The silver inkstand most likely was a preexisting design created to honor a British military victory, possibly during the Crimean War, which ended in 1856. The Liverpool Southern Club likely purchased the inkstand and then had it appropriately engraved for Spence. The women of the organization clearly paid attention to the American Civil War and chose the names and battles to glorify Confederate victories. The inkstand is almost fourteen inches tall, twenty-six inches wide, and nine inches deep, and it has twelve sections with space for engraving. The ladies of

the Liverpool Southern Club acquired the inkstand and had it customized as a gift for Spence in recognition of his assistance with a five-day-long fundraising bazaar at St. George's Hall in Liverpool.

It was 1864, and the Confederacy was struggling. Blockade runners were providing much-needed cotton to textile manufacturers in Liverpool and across northern England. American Southerners living in Liverpool tried to manipulate public opinion to the side of the Confederacy. British merchants and politicians fought to gain government support for the cause. One of those men was Spence, a founder of the Liverpool Southern Club. As a main proponent of Confederate support in Great Britain, he wrote several pamphlets and articles arguing the Confederate cause.[7]

The Liverpool Southern Club, founded in 1862, tried to keep its membership list secret. Members included prominent American southerners living in Liverpool, and their British supporters, like Spence.[8] The American consul in Liverpool, Thomas Dudley, estimated that the club had about two hundred members and said it was "dominated by those involved in the Southern trade."[9] During the Civil War, members raised money to support the Confederacy and to sway British public opinion to their side.

Dudley had replaced a pro-Southern consul in Liverpool who had been recalled by President Abraham Lincoln. Liverpool supplied many ships to the Confederate navy, and it was the duty of Lincoln's Liverpool men to deter them and prevent the British government from recognizing the Confederacy.[10] Shipbuilders in Liverpool made a lot of money selling to the Confederate Navy, and they fought to continue that trade. Spence was also involved in the scheme to sell ships to the Confederacy. He bought a blockade-running ship in 1863 and resold it to new owners, making a profit.[11] The Union Navy captured another blockade-running ship that Spence owned, which undoubtedly hurt his bottom line.[12] Several prominent members of the Liverpool Southern Club were also involved in blockade running.[13]

Blockade running not only brought in revenue to shipbuilders, it brought cotton to the textile mills in Liverpool. Southern states needed Liverpool. At the start of the Civil War, the Confederate states shipped sixty percent of their cotton to Liverpool. There were four million textile workers in England, and eighty percent of them were in Lancashire, where Liverpool is located. Although textile workers represented only fourteen percent of the total workforce, they were an important part of the Lancashire economy.[14] As early as 1810, the British government and public wrestled with the "slave question"—Was U.S.-produced cotton sustainable if it relied on slave labor? If enslaved people rebelled, sabotaged crops, or slowed production, what would that mean for the British textile industry?[15] Liverpool had

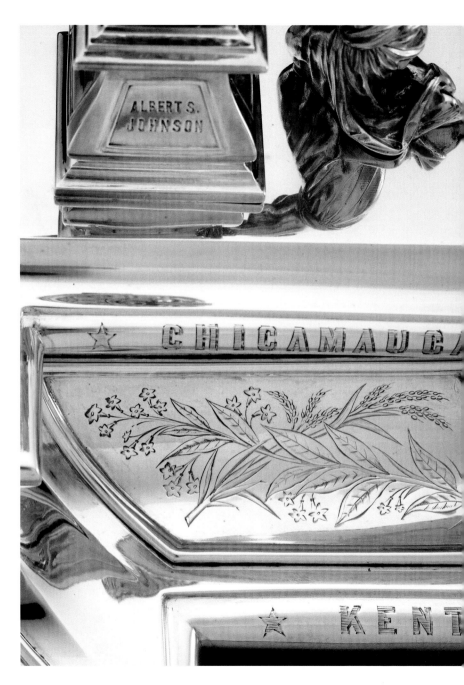

Fig. 5. On the back of the inkstand, on the bottom tier, is engraved the name of Kentucky; on the bottom circular pier, Georgia, Florida, and Alabama are named.

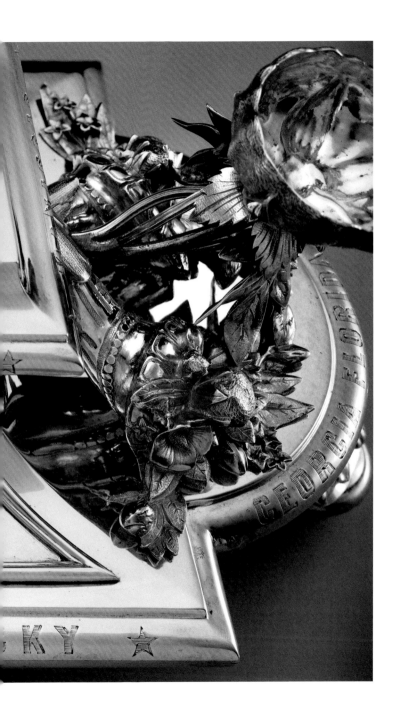

the most cotton importers in the United Kingdom. By 1820, 607 merchants in the area traded in cotton, although that number dropped as cotton trading concentrated in the hands of fewer and fewer wealthy men, men like Spence and the members of the Liverpool Southern Club.[16] The Confederacy needed Liverpool, and Liverpool cotton merchants and textile factories needed Confederate cotton.

The bazaar, held in October 1864, raised more than £20,000 to aid Confederate prisoners of war being held in the North. By focusing on prisoners of war, those attending the bazaar could distance themselves from the issue of slavery. Great Britain had abolished slavery in 1834, and the majority of the British public opposed slavery. Liverpool was the main stronghold of Confederate support in the United Kingdom. The glorification of the war dead and Confederate generals allowed those attending the bazaar to ignore the fact that the Confederacy was fighting to keep millions of people in bondage, and that the members of the Liverpool Southern Club profited from this enslavement.

Spence was treading a delicate line. He wanted Great Britain to recognize the Confederacy, thereby shoring up the textile industry. He knew, however, that the majority of the British public opposed slavery. Spence denounced slavery, while at the same time supporting the Confederacy and white supremacy.[17] He argued that once the Confederacy was independent, Southerners would see that gradual emancipation was the only course of action. In addition to his pro-Confederacy writings, Spence organized the only anti-Union meeting in all of England during the Civil War.[18]

The Liverpool Southern Club chose St. George's Hall, a Neoclassical building opened in 1854 in the center of the city, as the site of their bazaar.[19] In addition to stalls offering goods for sale, the bazaar offered entertainment, including music, piano recitals, pony rides, and a "Southern mermaid" on display. Mr. Frank Toole, a comic entertainer hired from London (he was the brother of famous comedian John Toole), displayed the "mermaid," and he was popular with the crowd.[20] Visitors to Toole's tent went into a "cave" to converse with the mermaid. The public only had to pay when emerging, and only if they were convinced. They all happily paid, and there was reportedly "much laughter and seductive conversations heard."[21] The ladies of the Liverpool Southern Club raffled items to raise money for their cause, including a pony and a Manx cat. The pony was raffled over and over, as each owner returned it to be auctioned again.[22] The Liverpool Southern Club purchased a sword and a Bible that they planned to send to Robert E. Lee. A large portrait of Stonewall Jackson looked out over the crowd.[23] The inkstand includes an engraved image of the bazaar's stalls, banners, and shoppers (fig. 2).

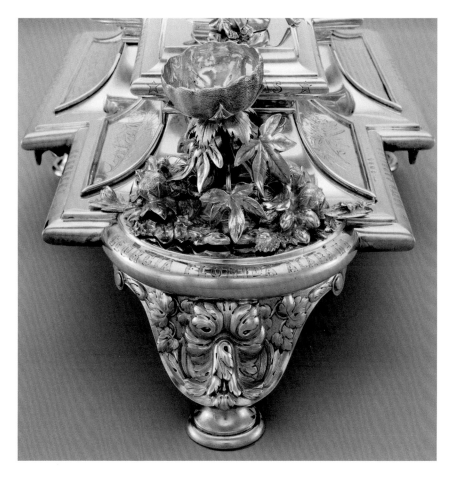

Fig. 6. Another view of the bottom tier listing Confederate states; the rounded edge is decorated with cotton pods and flowers native to the southern regions.

The wives of prominent Confederates residing in Liverpool hosted the bazaar alongside elite British women whose husbands also supported the Confederate cause. Each of the twelve Confederate states was represented. The main organizer was Mary Elizabeth Prioleau, a native of Liverpool; her husband, Charles Prioleau, from Charleston, South Carolina, was the most prominent Confederate in Liverpool. As the senior partner in the firm of Fraser, Trenholm & Co., he organized the majority of the financing for the Confederate navy.[24] Mr. and Mrs. Prioleau resided at number 19 Abercromby Square in Liverpool and were neighbors of the Spences, who lived at number 10. The South Carolina booth displayed autographs of Robert E. Lee, Jefferson Davis, General Pierre Beauregard, and Pope Pius IX.[25]

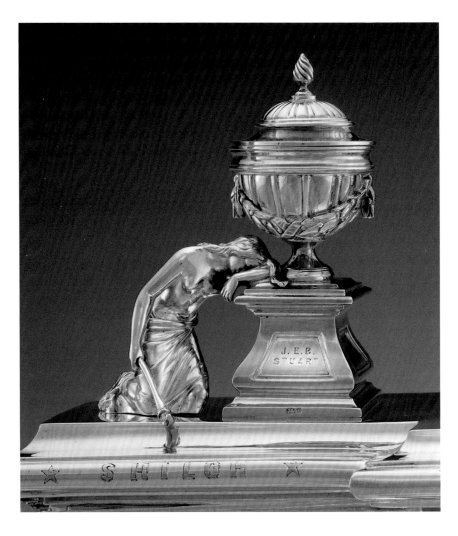

Fig. 7. An angel weeping on the memorial block of J.E.B. Stuart, on the front left side of the inkstand.

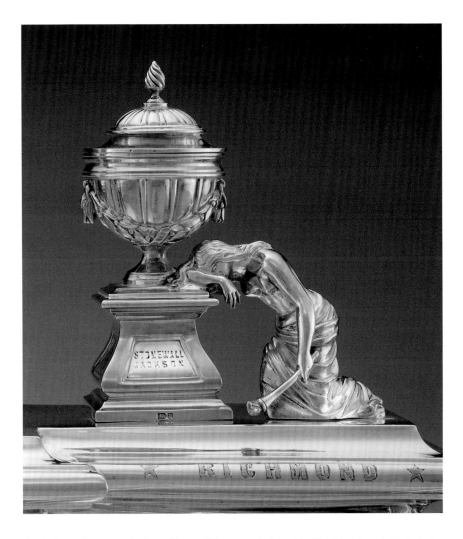

Fig. 8. An angel mourning the death of Stonewall Jackson on the front right side of the inkstand. On the back are the names of Albert Johnston (misspelled on the inkstand) and Leonidas Polk.

Among the women volunteering for the bazaar was Mathilde Slidell, who hosted the Mississippi booth with the Countess of Chesterfield, Anne Elizabeth Stanhope. The London Herald reported that the booth included bearskin rugs and Bohemian dolls.[26] Slidell's husband, John, was a Confederate diplomat who was involved in the Trent Affair, an incident between the United States and Great Britain in 1861. The Trent was a British ship carrying two Confederate envoys, one of whom was Slidell, to France to seek diplomatic recognition. Union forces stopped the ship in international waters and detained the two men, leading to outrage across the United Kingdom.[27] Slidell resigned as the U.S. Senator from Louisiana when that state seceded.

The Texas booth sold jewelry, timepieces, tapestries, and "richly-worked screens." Mrs. Arthur (Lucy) Forwood, her sister-in-law Mrs. William Forwood, and Mrs. W. Heyn tended the booth.[28] Arthur Bower Forwood, born in Liverpool was a partner in the steam navigation company Leech, Harrison & Forwood.[29] Forwood's family was involved in the cotton business, and he and his younger brother William made a fortune as blockade runners during the Civil War.[30] Arthur publicly displayed a Confederate flag in 1861 from his Liverpool office window.[31] Forwood's son was arrested in New York for "suspicion of Southern tendencies."[32] Arthur would later serve as the Lord Mayor of Liverpool.

The Virginia stall displayed a sword, to be presented to General Lee, that was decorated with gold and the inscription: "Presented to Major-General Robert E. Lee, from the Virginia stall of the Southern Bazaar, at Liverpool, October 18, 1864." The sword was provided by a London-based silver and jewelry store.[33]

The inkstand represents the idealized version of the Confederacy. Victory stands at the top with a raised sword, signaling that the Liverpool Southern Club still held out hope that the Confederacy would prevail (figs. 3–4). The names of the Confederate states are engraved on the tiers and under the stylized cotton plants on the ends (figs. 5–6).

Two mourning figures draw attention to the men killed fighting on the Confederate side. Along the edges of the tiers are the names of significant Confederate battles, including Bull Run, Chancellorsville, and Shiloh. More than six hundred thousand men died by the end of the Civil War. As historian Drew Faust pointed out, it was the duty of a soldier to die. They had to prepare themselves for this noble journey to a "good death," which was patterned on the death of Christ.[34] Soldiers took locks of their loved ones' hair and prewritten farewell letters onto the battlefield, where they often died alone or surrounded by strangers, instead of the Victorian ideal of dying at home surrounded by family.[35] Hasty battlefield burials meant that many soldiers would remain forever unidentified and forever lost to their families.

*Fig. 9. Josephus Holtzclaw Lakin, **Picking Cotton near Montgomery, Alabama**, 1860, albumen stereograph, Library of Congress, Prints and Photographs Division, Washington, DC.*

The inkstand also glorifies well-known "heroes" of the Confederate military, such as Robert E. Lee and Jefferson Davis. Others, like Leonidas Polk, who was controversial for his lack of success in battle, died during the Atlanta Campaign in June 1864. Polk had no previous military experience, and served as a bishop in the Episcopal Church. The bazaar was held only four months after his death. Other Confederate dead honored in this mourning piece included J.E.B. Stuart, who was killed in May 1864, and Stonewall Jackson, killed in 1863 (figs. 7–8). General Albert S. (Sidney) Johnston (see also fig. 5) was the highest-ranking officer killed during the Civil War on either side. He was killed in 1862 in Tennessee. These names are engraved on the plinth holding the urn with weeping angels draped over them. This is the epitome of Victorian mourning culture.

The ladies of the Liverpool Southern Club also had engraved the names of John Calhoun, who had died a decade earlier, and presidents George Washington and James Madison. The women chose to include them as they were Southerners and slaveholders. Slaves and the "slave question" played a central role in the South's decision to secede. Invoking Washington's name gave validity to the work of Spence and the Liverpool Southern Club; he was the first president of the United States, and he had vast holdings of slaves. More than three hundred enslaved people lived on Washington's Mount Vernon estate.[36] Madison owned more than one hundred enslaved people.[37] Calhoun wrote extensively about the slave question and for the need for the South to secede (fig. 9).[38]

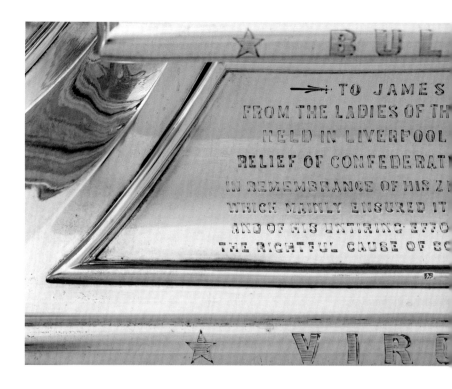

Why the ladies did not include Jefferson, who owned more than six hundred enslaved persons, remains a mystery. Enslaved people resisted, regardless of how grand their enslaver was, or how kindly they were supposedly treated. George and Martha Washington tried unsuccessfully to retrieve their runaway slave Ona Judge.[39] Slave resistance made cotton a risky venture, and the fact that the members of the Liverpool Southern Club's livelihoods depended upon the labor of enslaved people led them to support the institution.

That support is evident in the main inscription on the inkstand (fig. 10), which reads:

TO JAMES SPENCE
FROM THE LADIES OF THE SOUTHERN BAZAAR
HELD IN LIVERPOOL OCT:1864 FOR THE
RELIEF OF CONFEDERATE PRISONERS OF WAR
IN REMEMBRANCE OF HIS ZEAL AND PERSEVERANCE
WHICH MAINLY ENSURED ITS UNEQUALLED SUCCESS
AND OF HIS UNTIRING EFFORTS IN THE DEFENCE OF
THE RIGHTFUL CAUSE OF SOUTHERN INDEPENDENCE

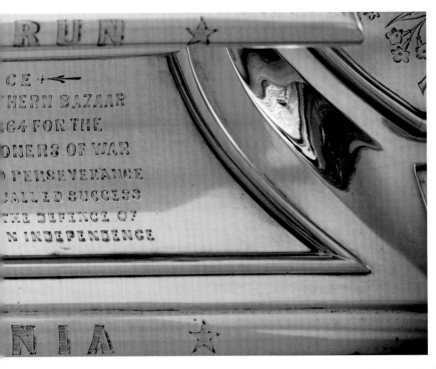

Fig. 10. Detail of the inkstand with the engraved dedication to James Spence, recognizing his work on the behalf of Confederate prisoners of war.

Like the sword intended for Robert E. Lee, the elaborate inkstand for Spence is representative of the Victorian taste for grand presentation pieces for "heroic" persons and deeds, and to commemorate notable events.[40]

The Confederacy lost the war just a few months after the bazaar. Robert E. Lee surrendered to Union General Ulysses S. Grant in April 1865. The money raised at the bazaar was never given to the support of Confederate prisoners of war (fig. 11). When Spence and Prioleau tried to send the money to the United States, they sent Lady Wharncliffe as their delegate. She had worked in the South Carolina stall with Mary Prioleau. Wharncliffe met with Charles Adams, the United States envoy to the United Kingdom. Adams passed the request on to Secretary of State William Seward, who soundly rejected the offer, saying that Confederate prisoners of war were not mistreated and did not need the money. He also accused many British citizens of war profiteering. Thwarted, Spence and Prioleau held the money until the end of the war, and then sent it to New York.[41]

After that point, the money is difficult to trace, and it is not clear if it made it into the hands of any Confederate soldiers (fig. 12). One could speculate that if the ladies of the Liverpool Southern Club were truly concerned about the wellbeing of Confederate prisoners of war, they would have donated more money, instead of spending it on an elaborate sterling silver inkstand for James Spence.

Top to bottom:
Fig. 11. Chas. Shober & Co., **Camp Douglas, Chicago, Ill**. *[which served as the primary prison for Confederate prisoners of war], 1864, lithograph, Library of Congress, Prints and Photographs Division, Washington, DC.*

Fig. 12. Mathew Brady, **Three "Johnnie Reb" Prisoners, captured at Gettysburg**, *c. July 15, 1863, albumen print, Library of Congress, Prints and Photographs Division, Washington, DC.*

Notes

1 Mr. Garrard to Miss Hogg, May 1, 1967, the Museum of Fine Arts, Houston, Archives.

2 *The Daily Mail*, July 15, 2007, "Queen Hires a new Crown Jeweler—after 160 years of Garrard."

3 John M. Graham II to Miss Hogg, January 31, 1967, the Museum of Fine Arts, Houston, Archives.

4 "International Saleroom," *The Connoisseur*, November 1966, 181.

5 Philippa Glanville, *Silver in England* (New York: Holmes & Meir, 1987), 126–27.

6 Glanville, *Silver in England*, 130, and Angus Patterson, "'A National Art and a National Manufacture': Grand Presentation Silver of the Mid-Nineteenth Century," in "Decorative Art: Exhibitions and Celebrations," ed. Anne Ceresole, *The Journal of the Decorative Arts Society 1850–the Present* 25, (2001): 59.

7 R. M. J. Blackett, *Divided Hearts: Britain and the American Civil War* (Baton Rouge: Louisiana State University Press, 2001), 15.

8 Blackett, *Divided Hearts*, 62–63.

9 Blackett, *Divided Hearts*, 63.

10 Coy F. Cross II, *Lincoln's Man in Liverpool: Consul Dudley and the Legal Battle to Stop Confederate Warships* (DeKalb, Ill.: Northern Illinois University Press, 2007), 7.

11 Stephen R. Wise, *Lifeline of the Confederacy: Blockade Running During the Civil War* (Columbia, SC: University of South Carolina Press, 1988), 309.

12 Wise, *Lifeline of the Confederacy*, 316.

13 Wise, *Lifeline of the Confederacy*, 46-47.

14 Douglas B. Ball, *Financial Failure and Confederate Defeat* (Urbana and Chicago: University of Illinois Press, 1991), 66.

15 Sven Beckert, *Empire of Cotton: A Global History* (New York: Alfred A. Knopf, 2015), 121.

16 Beckert, *Empire of Cotton*, 211.

17 Duncan Andrew Campbell, *English Public Opinion and the American Civil War* (Suffolk: Royal Historical Society, The Boydell Press, 2003), 27.

18 Campbell, *English Public Opinion and the American Civil War*, 67.

19 Historic England, "St. George's Hall, Liverpool," https://historicengland.org.uk/listing/the-list/list-entry/1361677 (retrieved February 5, 2019).

20 "The Southern Bazaar," *Daily Courier* (Liverpool), October 20, 1864.

21 "The Southern Bazaar," *Daily Courier* (Liverpool), October 19, 1864.

22 John Hussey, *Cruisers, Cotton and Confederates: Liverpool Waterfront in the Days of the Confederacy* (Birkenhead, UK: Countyvise, 2008), 122.

23 Blackett, *Divided Hearts*, 185.

24 Thomas E. Sebrell II, *Persuading John Bull: Union and Confederate Propaganda in Britain, 1860–65* (Lanham, Md.: Lexington Books, 2014), 184.

25 "The Southern Bazaar," *Liverpool Mail*, October 22, 1864.

26 "Southern Bazaar," *London Times*, October 18, 1864.

27 Campbell, *English Public Opinion and the American Civil War*, 61–65.

28 "Southern Bazaar," *London Times*, October 18, 1864.

29 Sebrell, *Persuading John Bull*, 184.

30 Philip Waller, "Forwood, Sir Arthur Bower (1836–1898)" and J. R. Killick, "Forwood, Sir William Bower (1840–1928)," *Oxford Dictionary of National Biography* (Oxford: Oxford University Press, 2004.)

31 Blackett, *Divided Hearts*, 63.

32 Blackett, *Divided Hearts*, 63.

33 "The Southern Bazaar," *Liverpool Mail*, October 22, 1864.

34 Drew Gilpin Faust, *This Republic of Suffering: Death and the American Civil War* (New York: Vintage Books, 2009), 4–6.

35 Faust, *This Republic of Suffering*, 27–30.

36 Erica Dunbar, *Never Caught: The Washingtons' Relentless Pursuit of the Slave, Ona Judge* (New York: Simon and Schuster, 2017), 8. Dunbar mentions only the 155 slaves owned by Washington's wife, Martha Dandridge Custis Washington; George Washington owned slaves as well. Dunbar states that number increased through purchase and by slave women having children. The official Mount Vernon website states that the Washingtons owned 317. See "Slave Quarters," George Washington's Mount Vernon, https://www.mountvernon.org/library/digitalhistory/digital-encyclopedia/article/slave-quarters/.

37 Pamela Newkirk, "Slavery and the Contradictions of James Madison," *Washington Post*, January 5, 2018.

38 Eric Walther, *Fire Eaters* (Baton Rouge: Louisiana State University Press, 1992), 134–36.

39 Dunbar, *Never Caught*, 99–117.

40 Elizabeth Ingerman Wood and Thomas Fletcher, "A Philadelphia Entrepreneur of Presentation Silver," *Winterthur Portfolio* 3 (1967): 141.

41 Sebrell, *Persuading John Bull*, 187–88, 196–97.

From left to right: Marion Oettinger, Jr., Donna Pierce, Mark Goldberg, Evelyn Montgomery, Theresa R. Jach, Marjorie Denise Brown, and Harry J. Shafer.

Contributors

Marion Oettinger, Jr., is curator emeritus of Latin American art at the San Antonio Museum of Art.

Evelyn Montgomery is curator of the Old Red Museum of Dallas County Heritage and Culture.

Donna Pierce is the former Frederick and Jan Mayer Curator of Spanish Colonial Art at the Denver Art Museum.

Harry J. Shafer is an archaeologist, professor emeritus at Texas A&M University, and curator of archaeology at the Witte Museum, San Antonio.

Mark A. Goldberg is associate professor in the department of history at the University of Houston.

Marjorie Denise Brown is an instructor in the department of history at Houston Community College.

Theresa R. Jach is an instructor in the department of history at Houston Community College Northwest.

Photograph Credits

They Walked Among Us: Six Who Shaped Eighteenth-Century Texas
Fig. 3: Photograph by the author.
Fig. 10: Photograph by Gabriela Gámez.
Fig. 11: Photograph © Oscar Marquez.

House-Proud in Texas: The Struggle for a Proper Frontier Home
Fig. 12: Photograph by the author.

Haciendas, Homes, and Household Furnishings in Spanish Colonial New Mexico
Fig. 5: Photograph by James Milmoe.
Fig. 6: Photograph © The State Hermitage Museum, St. Petersburg; photograph by Pavel Demidov.
Fig. 8: © Museum of International Folk Art; photograph by Ernst Luthi.
Fig. 11: Photograph by The Conservation Center.
Fig. 14: © Museum of International Folk Art; photograph by Blair Clark.
Fig. 20: © Museum of International Folk Art; photograph by Ruth LaNore.
Fig. 24: © Museum of International Folk Art; photograph by Carrie Haley.

Material Culture in Texas Prehistory: Shaping Nature's Raw Materials
Figs. 1, 2, 7, 11, 13, 18, 23: Photographs by Milton Bell, Texas Archeological Research Laboratory, University of Texas at Austin.
Figs. 3, 20, 21, 22, 24, 25, 26, 27, 28, 29: Photographs by Al Rendon.
Fig. 4: Photograph by Bryan Jamison.
Fig. 9: Photograph by Thomas Hester, the Texas Archeological Research Laboratory, University of Texas at Austin.
Fig 15: Photograph by Thomas R. DuBrock, department of photographic and imaging services, the Museum of Fine Arts, Houston.
Fig. 19: Photograph by John Copp, courtesy of the Department of Anthropology, Texas A&M University, College Station, Texas.
Fig. 30: Photograph courtesy of the Shumla School, Comstock, Texas.

A Confederate Inkstand in England: Pro-Confederate Cotton Elites in Liverpool
Figs. 1–8, 10: Photographs by Thomas R. DuBrock, department of photographic and imaging services, the Museum of Fine Arts, Houston.

Page viii: Photograph by Will Michels, department of photographic and imaging services, the Museum of Fine Arts, Houston.
Page xi: Photographs by (upper left) Paul Hester; (lower left and right) Thomas R. DuBrock, department of photographic and imaging services, the Museum of Fine Arts, Houston.
Page 152: Photograph by Jacob Power.
Page 154: Photograph by Rick Gardner.

Left: Bayou Bend